United States of LEGO ®

An Unofficial Unauthorized Guide

United States of LEGO®

A Brick Tour of America

Jeff Friesen

Skyhorse Publishing

Visit our website at www.skyhorsepublishing.com.

10 9 8 7 6 5 4 3 2 1

Library of Congress Cataloging-in-Publication Data is available on file.

Cover design by Rain Saukas
Cover photo credit © Jeff Friesen

ISBN: 978-1-62914-682-9
Ebook ISBN: 978-1-62914-846-5

Printed in China

For Tetjana and June

Table of Contents

[1] Federal district, not a state

Introduction

Making sense of a big country is like taming a horse-sized turkey. There are a few ways to do it, but how do you begin such an epic task? One big country, the United States of America, solves this dilemma with its customary can-do spirit. The USA has helpfully portioned itself into fifty bite-sized morsels, called states, to aid in its overall digestion. Get a taste of all fifty states, and the vast buffet table of America reveals its essential flavor.

Some say the whole is greater than the sum of its parts, but residents of different states prefer to tell you how their state is better than yours. It is true that every state is as unique as a traffic-stopping snowflake in Atlanta. The founders wisely counseled that each state should be a different shape in order to help distinguish one from the other.

Looking closely at a state's shape often provides a handy clue to its identity. Michigan, for example, resembles a mitten. That reminds you that Michigan is cold, so you should knit yourself some winter attire before visiting. Oklahoma is the shape of a frying pan, which is exactly what you will need to fry up the tender beasts grazing there. Minnesota's eastern border is an exact contour of Garrison Keillor's profile, foreshadowing that you will soon be asked to give money to a radio station.

The traditional way to visit the states is by setting out on a great American road trip. The interstate highway network, a marvel of ingenuity, grit, and corrupt construction bosses, allows you to whisk

across the country like a clever cartoon roadrunner. Conveniently spaced travel plazas will provide you with both food and powerful gas. You can also get gas for your car. The only peril with roadside food is stacking so many cheeseburgers in your gullet that it is only possible to leave your car by greasing its doorframe with chicken nugget juice.

That said, you will be able to enjoy many of the open road's wonders while sitting behind the steering wheel. Where else will you be able to gaze at the wondrous piles of newly discovered lint from your pocket as you search ever deeper for coins to feed New Jersey Turnpike tollbooths? Where else will you see the sun rising over the heartland while your car is sandwiched between two Wonder Bread trucks? Where else will an RV grow alarmingly in your rearview mirror as its venerable driver is distracted by an episode of *The Golden Girls* playing on his dash-mounted DVD player?

Road trips are not all fun, however. Carefree travel only applies to the contiguous lower forty-eight states. The tunnel to Hawaii is under constant repair by hammerhead sharks, and traffic is always backed up in the doldrums. Driving to Alaska requires a hazardous transit through frosty Canada, where the inhabitants are so rude they will only apologize in three different ways if you back over one of their pet beavers.

Perhaps it's best to avoid getting kicked on Route 66 in favor of flying the friendly skies. Air travel lets you alight in each state and have a decent look around, like a bald eagle searching for a regal

toupee. Plane tickets are pricey, but there are practical ways to help with the costs. The best way to raise funds if you are an American-born citizen over the age of thirty-five is to run for president. Just be vague while asking for donations. If you do not meet those requirements, you can save on baggage fees by traveling without luggage. Many airlines will also eliminate the new clothing fees if you travel in your undergarments (though a surcharge remains for patterned fabrics).

Wait a second! It is impossible to visit all fifty states by air. Planes are banned from landing in the so-called flyover states due to new legislation borrowed from *Star Trek*'s Prime Directive. Basically, the folks in flyover states are bewildered by post-blunderbuss technology. It's best to keep them thinking that airplanes are messengers from the moon. Flyover states include every state without a major city called New York or Los Angeles (since the citizens of those cities invented the term and prefer connection-free flights).

Now that the shortcomings of plane and automobile travel have been exposed, let us consider the train. What could be more fitting than train travel in America? You can ride the iron horse that tamed the west and enriched the east, forever linking the two in a bond of steel. How better to contemplate the sheer Nebraska-ness of Nebraska when stopped on a siding for seven hours while passing freight trains get the right-of-way? After all, the details of a wheat field require several days of contemplation. Yes, if you have a free decade or two, taking the train is a truly exhaustive way to see the states.

If your schedule is too tight for train travel, only one realistic option for exploring the fifty states remains: armchair travel. You can simply buy a book about the fifty states and worm your way through pages of information in stationary comfort. The risks of motorized travel are replaced with the mere risk of a paper cut.

In fact, you can learn more from a book than from actual travel experience. Do you know that "Our Delaware" is the official state song of . . . Delaware? Are you aware that Crowley, Louisiana, is the "Rice Capital of America"? Have you fixed in your mind that Oregon laid down the nation's first one-way streets? You could spend years hunting down these and countless other pedantic facts about the United States of America, but why not opt instead for a book with funny and entertaining information about the states—even if some (most) of it is made up.

Once you find a humorous book about the fifty states, make sure it is lavishly decorated with photographs. In today's visually obsessed culture, a picture is worth ninety-eight rhyming poems, and that figure rises every day. The only problem with photography is that nowadays everyone carries a camera, and people are unafraid to take more photos of even extensively photographed scenes. Somewhere on the Internet you will find every corner of every state photographed in every lighting condition. Experts say there is a growing danger of scenery disappearing due to being overharvested by cameras.

You can do your part to save America's most photographed landmarks by seeking out a book with photographs of the fifty states that are obtained without using any real parts of the states. It sounds tricky, but museums have been using dioramas to represent actual places since the Popsicle stick was invented. A book featuring diorama photographs for each state would be a fresh way forward. If the dioramas were to be made of materials more cheerful than toothpicks and clay, then all the better . . . something clean and bright like LEGO bricks would be a charming choice.

Well, best of luck to you in locating such a bizarre book. If you ever do, your new discovery of the fifty states will be firmly in hand.

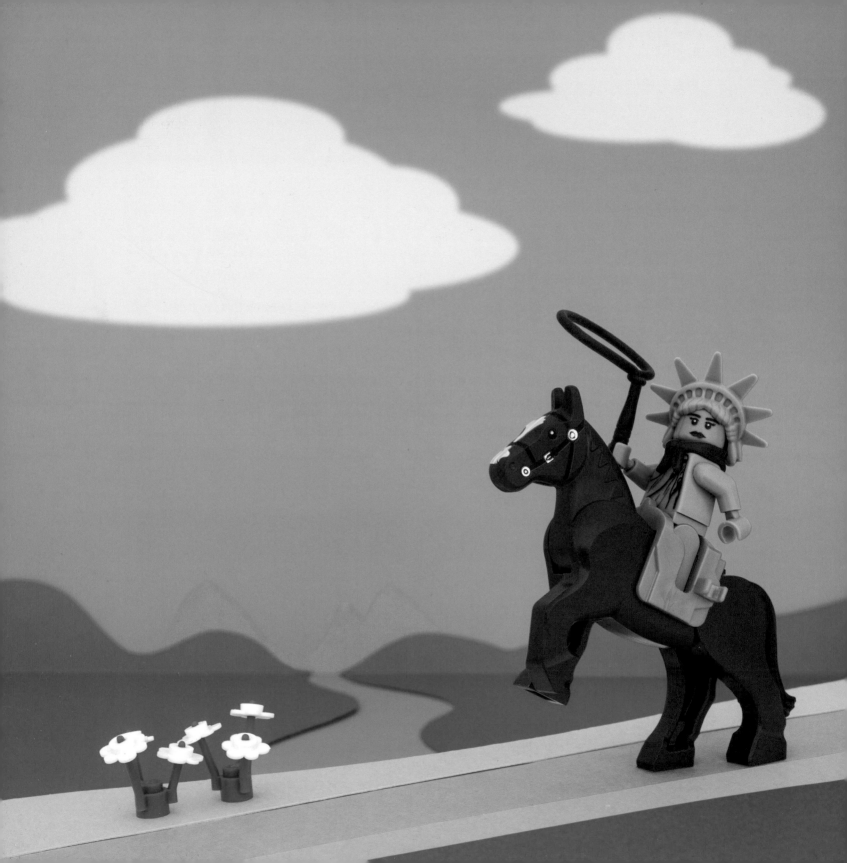

ALABAMA

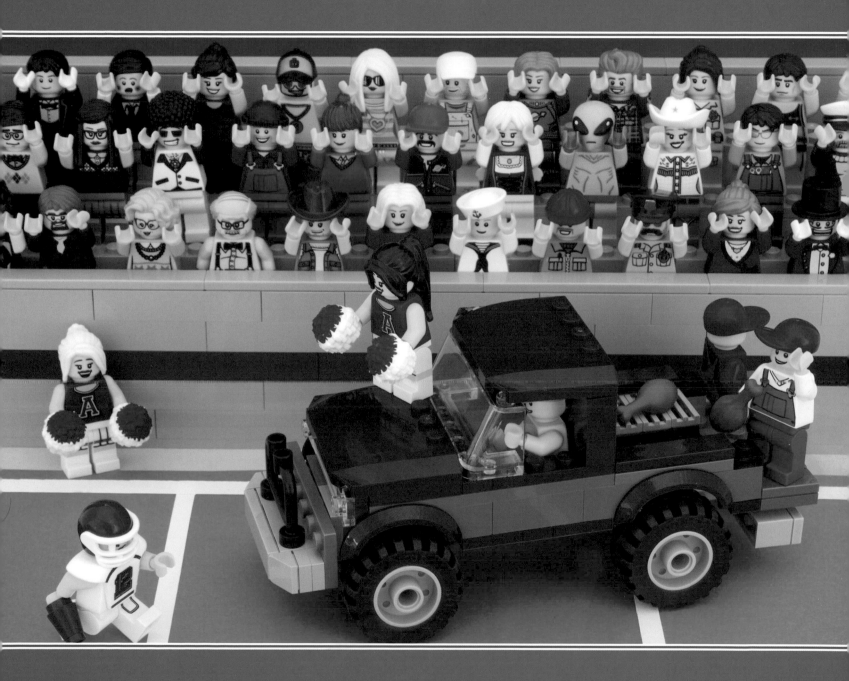

The rising Crimson Tide washes tailgaters onto the playing field—or so they later claimed to the referee.

ALABAMA

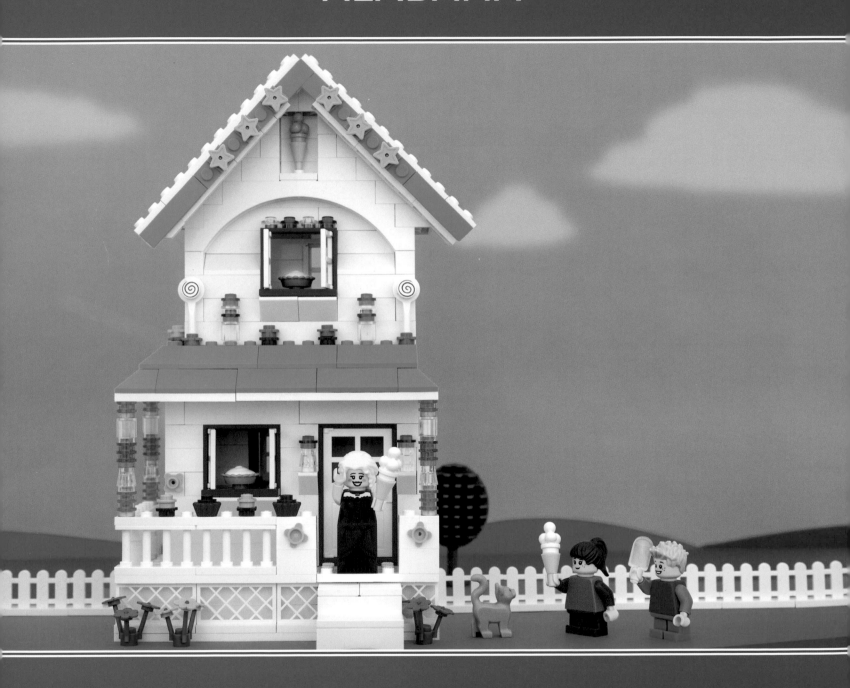

Sweet home Alabama.

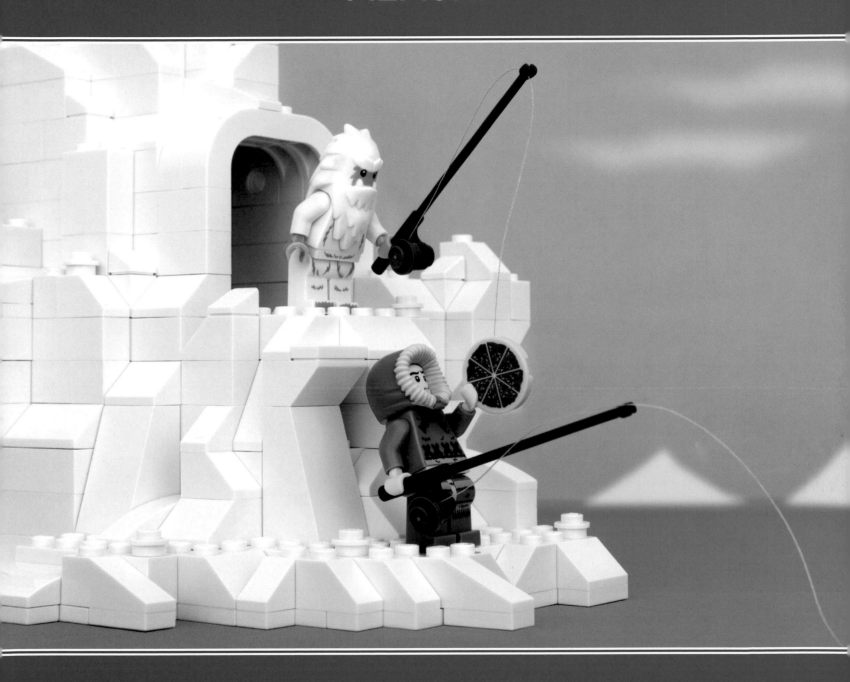

Give a man a fish and you feed him for a day.
Fish for a man and he is food for a week.

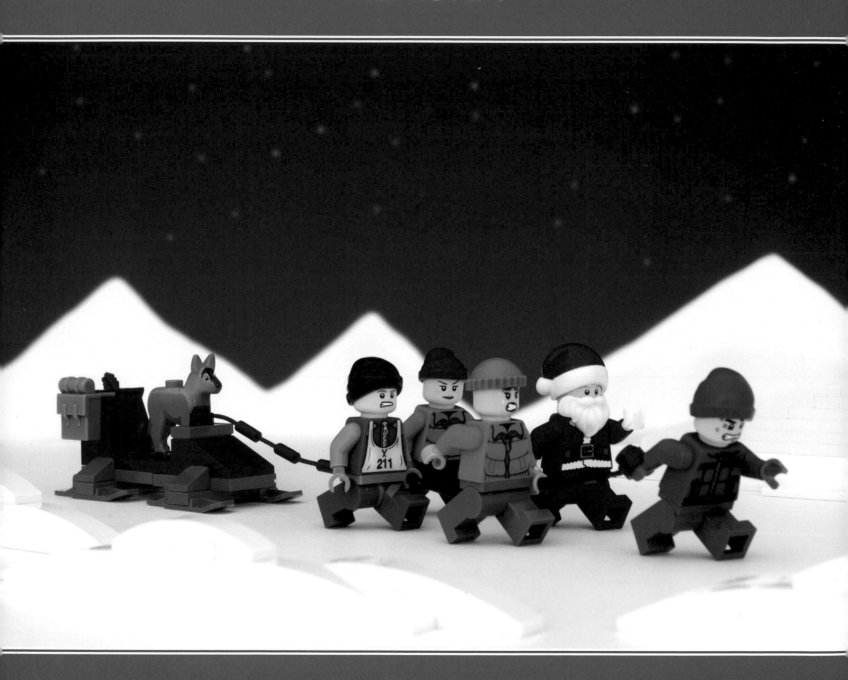

The Iditarod in 2037, shortly after dogs have taken over the Earth.

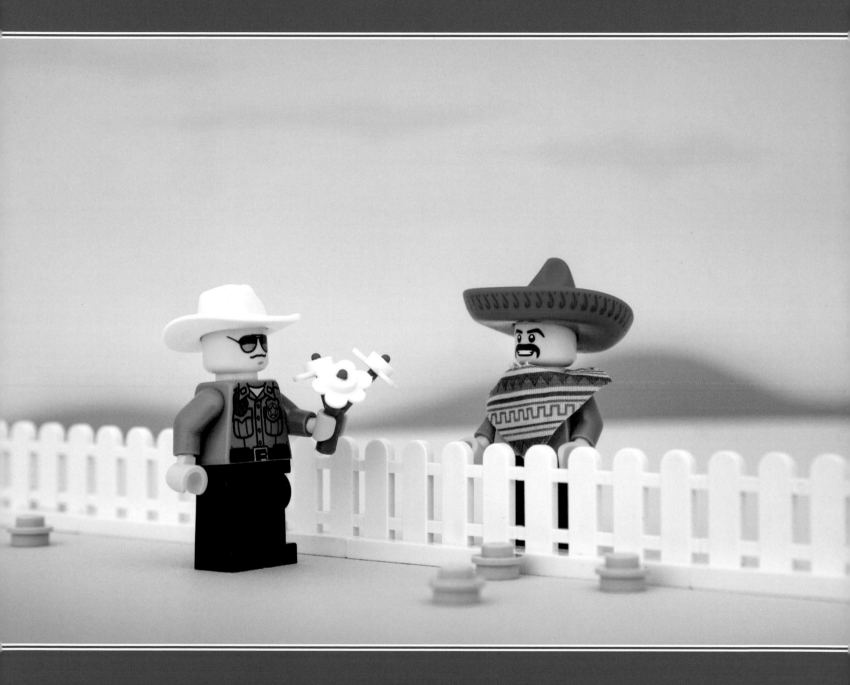

To be honest, John and Juan are still on the fence about their friendship.

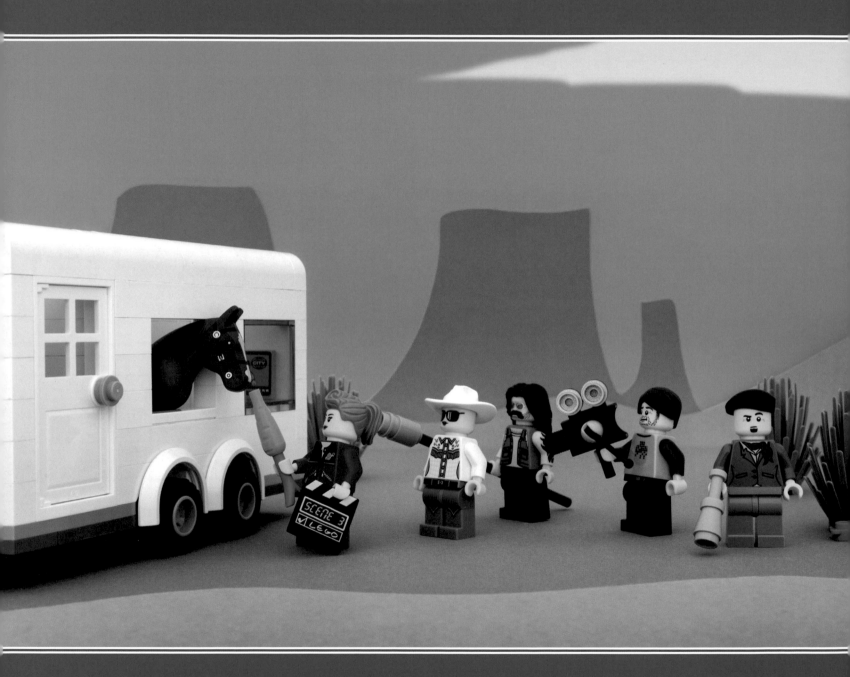

It's not all happy trails working with Trigger Longface Jr., who storms off to his trailer whenever the supply of imported demerara sugar cubes runs low.

ARKANSAS

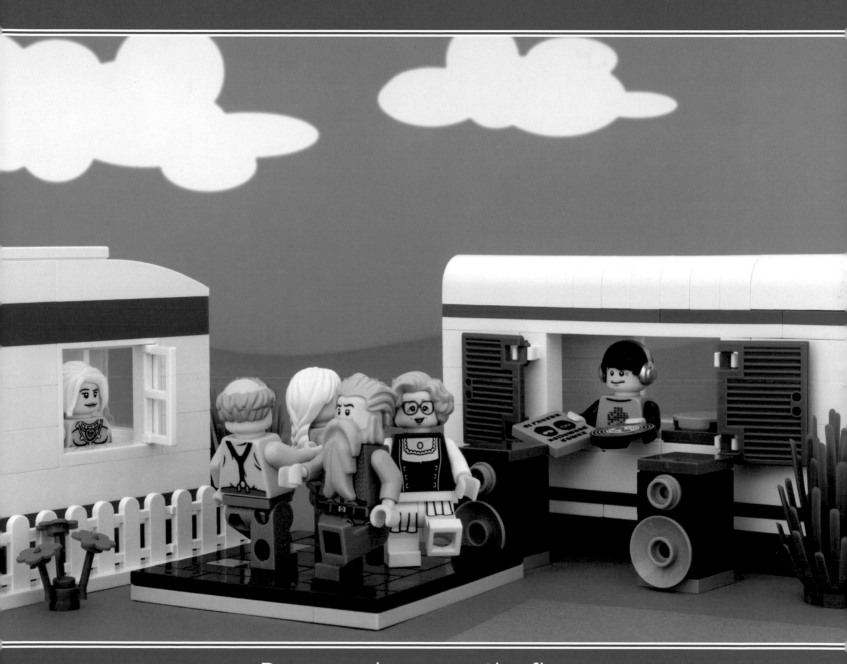

Promenade across the floor,
Shimmy right on out the door,
Henpeck a chicken, buff your cat,
These DJ beats are really fat.

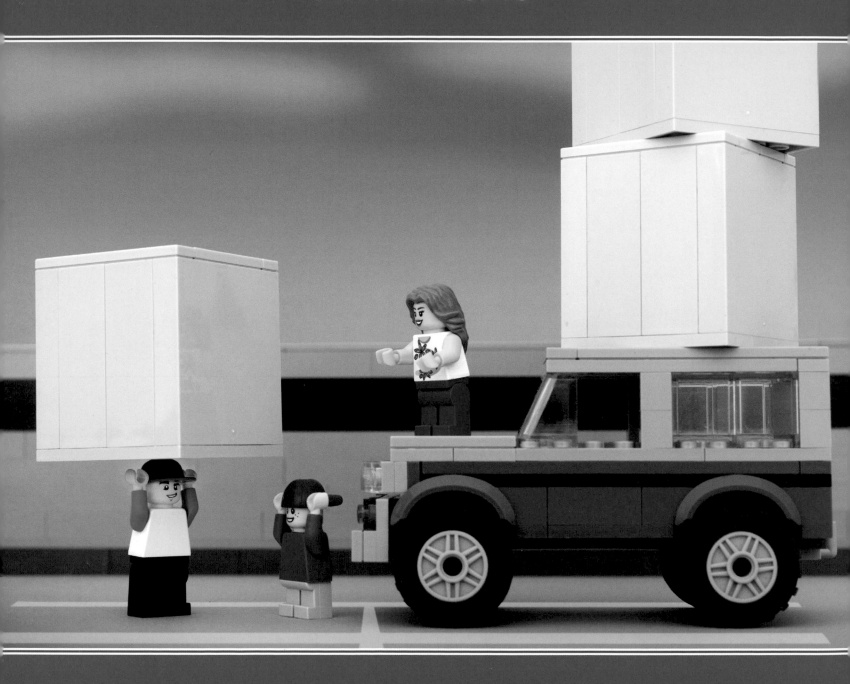

The Johnsons love a sale at the big box store.

CALIFORNIA

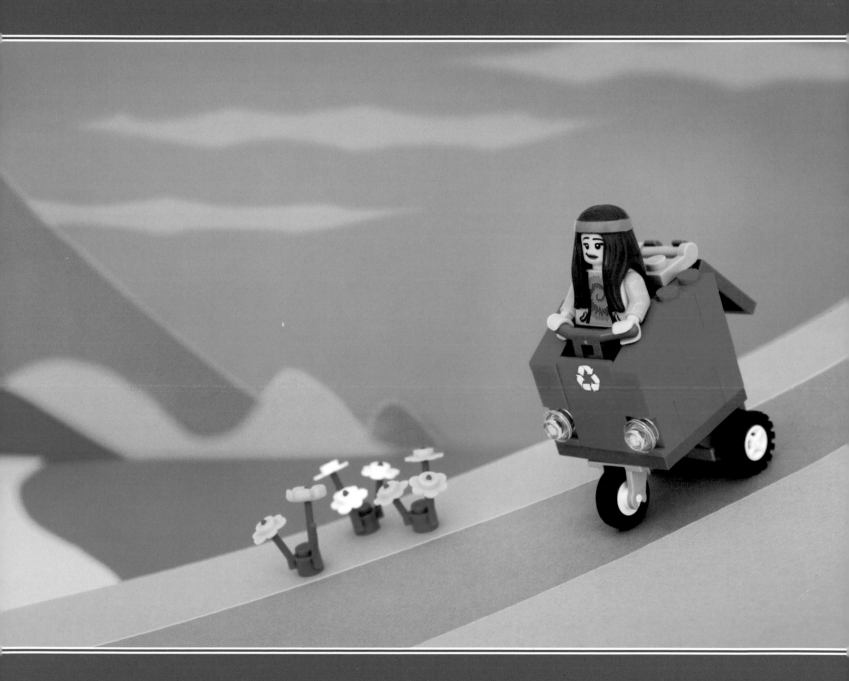

Moonbeam's compost-powered hybrid generates a respectable 32 fruit flies per rotting banana peel.

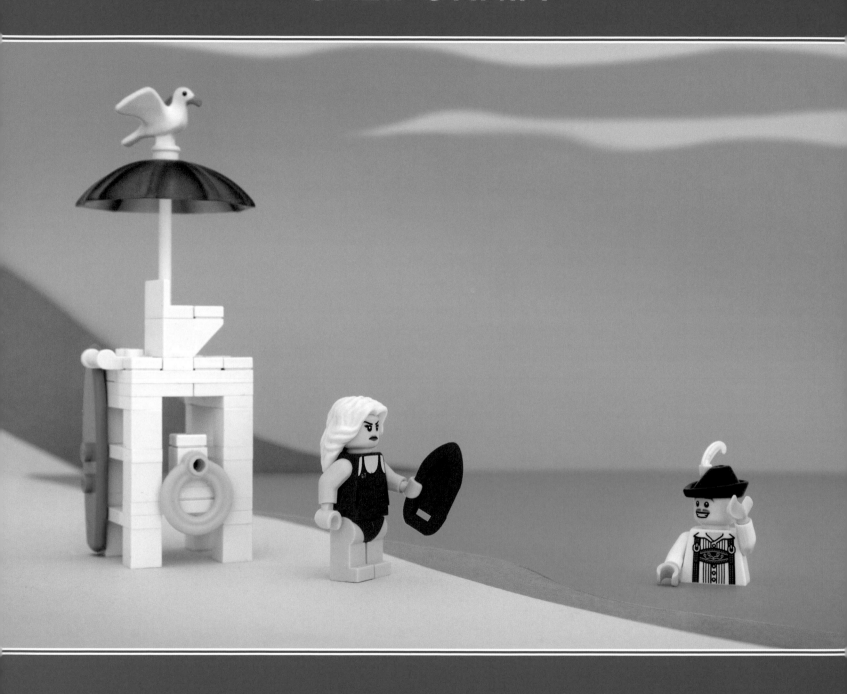

Despite Otto's sudden loss of swimming ability during Elektra's lifeguarding shift, he keeps going back in the water.

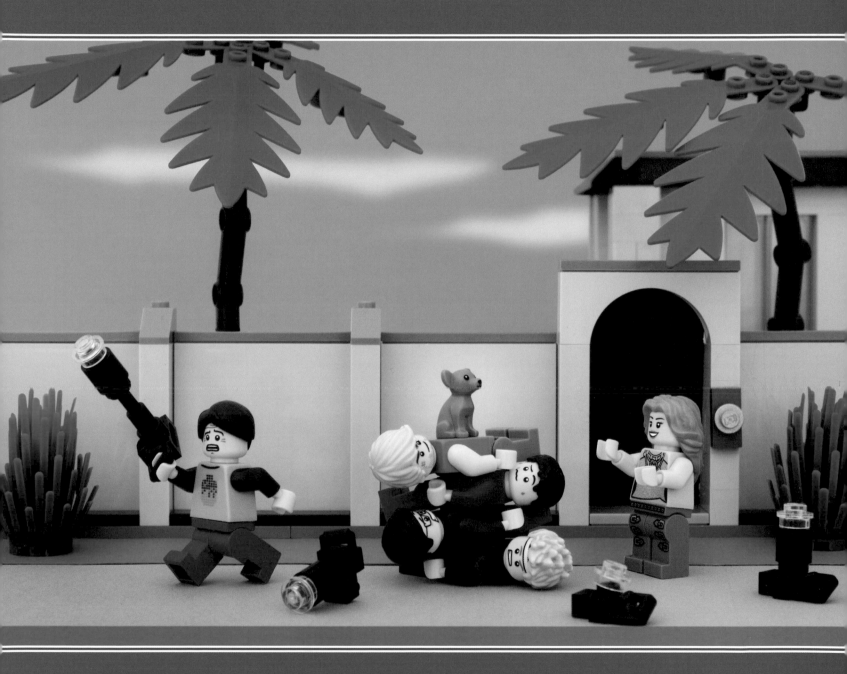

Referring to Twinkie-Poo as an accessory pet
was their first mistake.

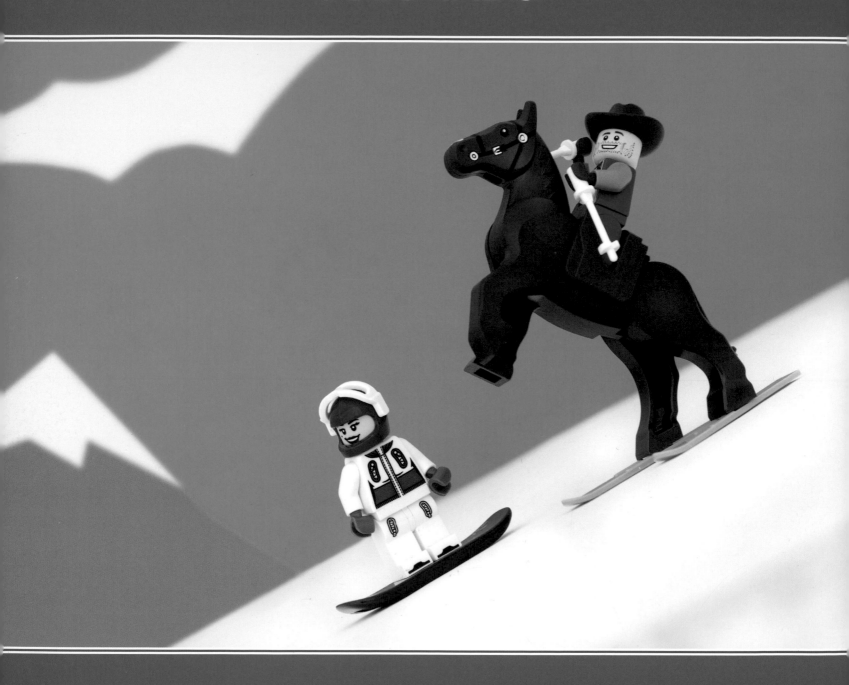

Head 'em up, move 'em out, send 'em down . . . the snowboard wranglers of Aspen hoof it on the slopes.

COLORADO

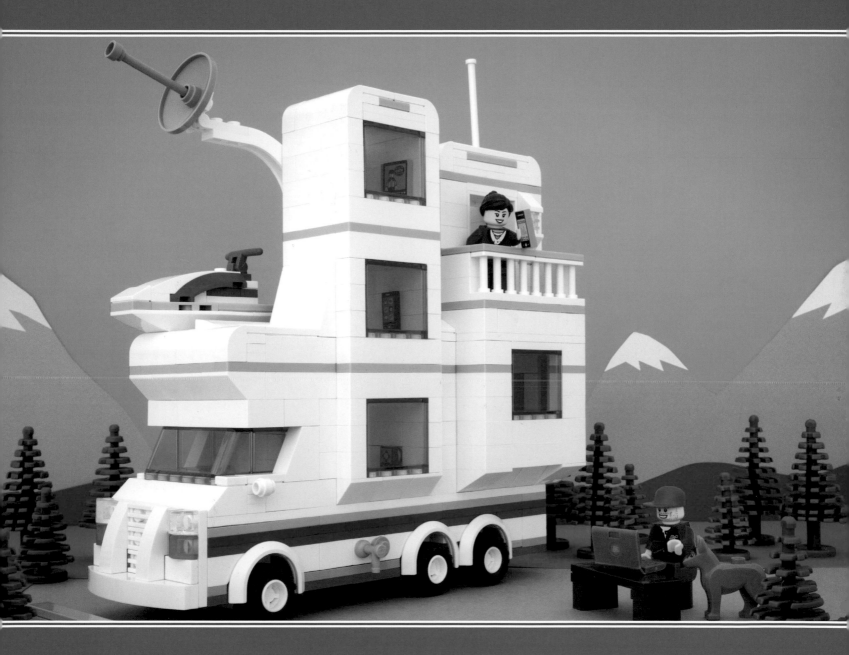

The Johnsons are as rugged as the Rocky Mountains they roam, having once survived two weeks of mild weather without seeing a new episode of *The Blingy Bull Moose* on satellite TV.

CONNECTICUT

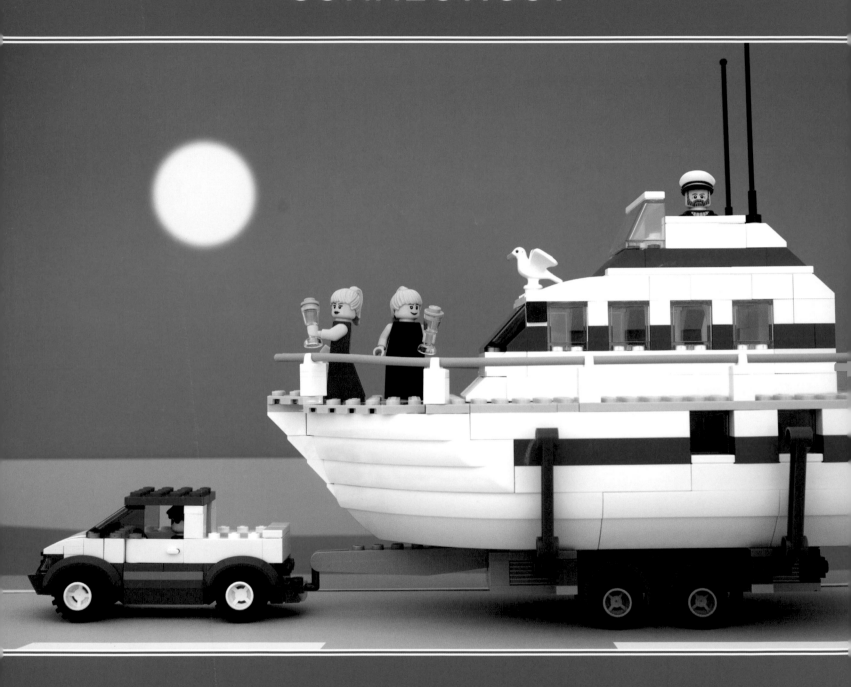

Cruising with the Stepford wives of I-95.

CONNECTICUT

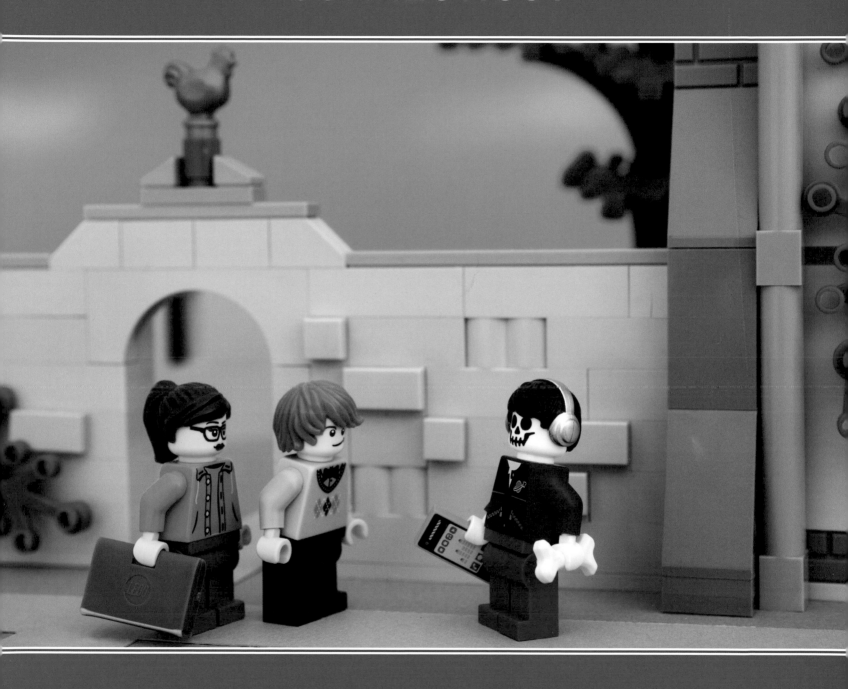

Members of Yale's Skull and Bones secret society are surprisingly easy to spot on campus.

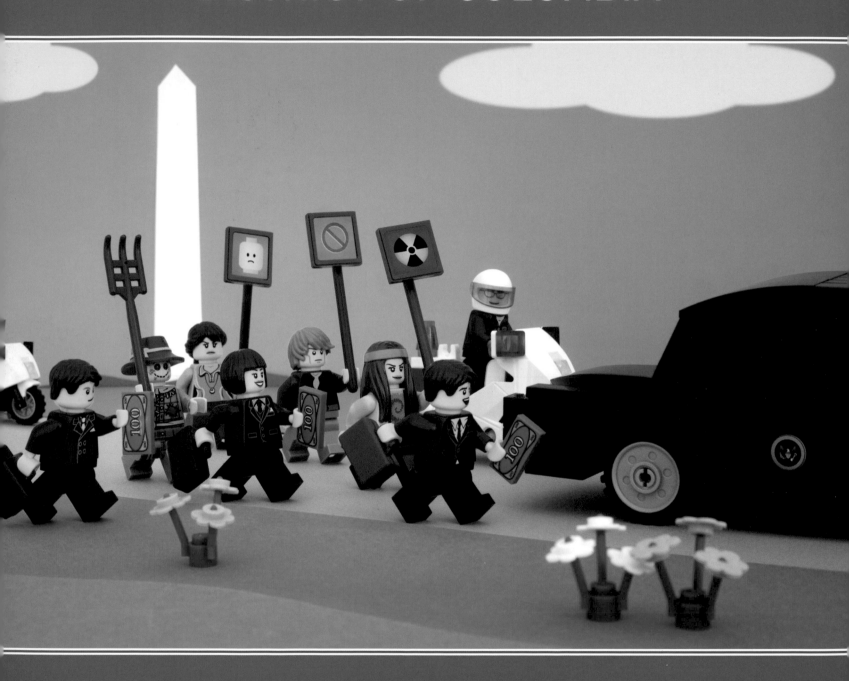

Exercising democracy burns about 370 calories per hour.

DELAWARE

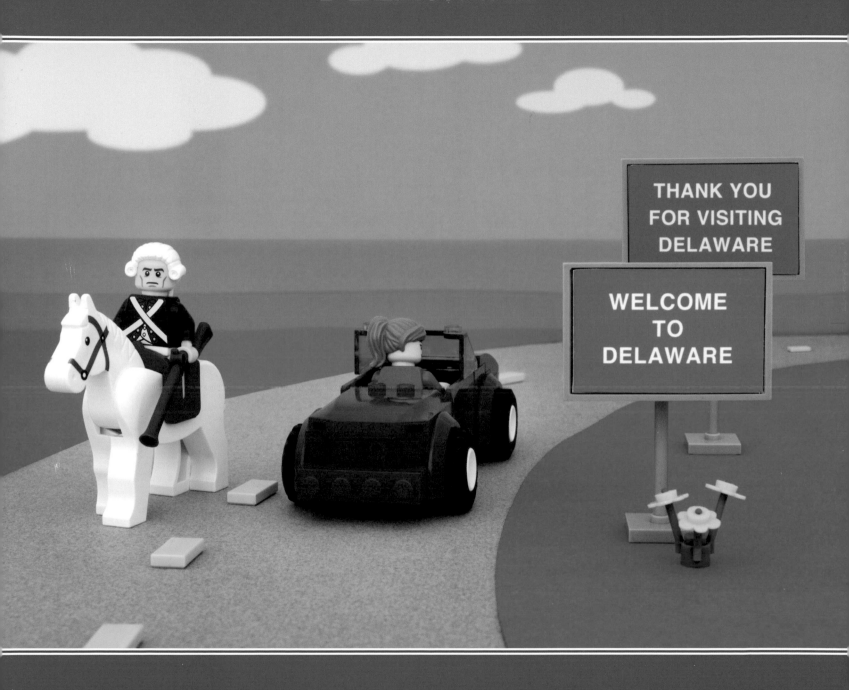

Inspired by Emanuel Leutze's famous painting,
Washington Crossing the Delaware.

FLORIDA

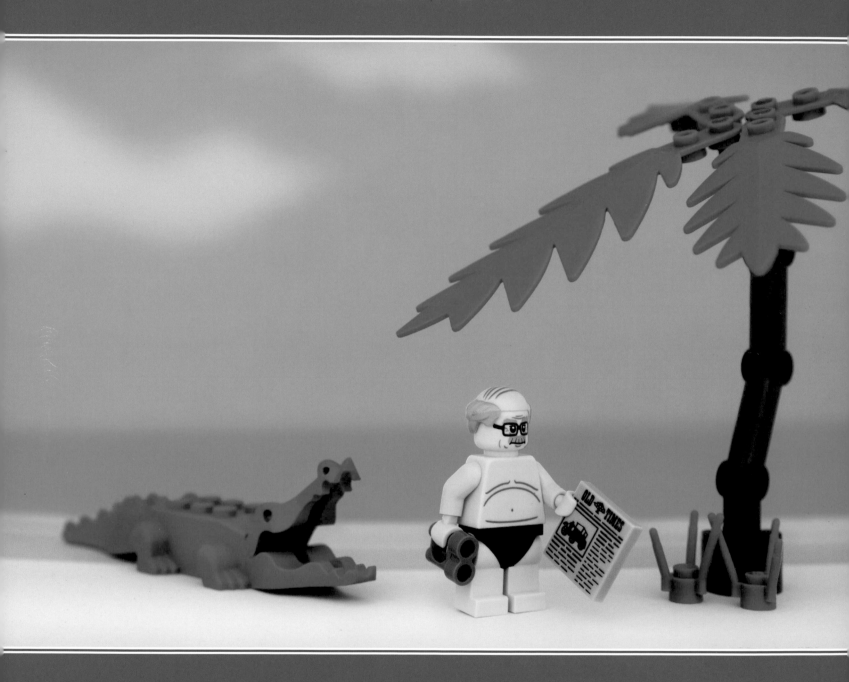

Reptilian life-forms rule the beaches of Florida. Most are slow-moving, but some will strike without warning at a 4:00 p.m. dinner special.

FLORIDA

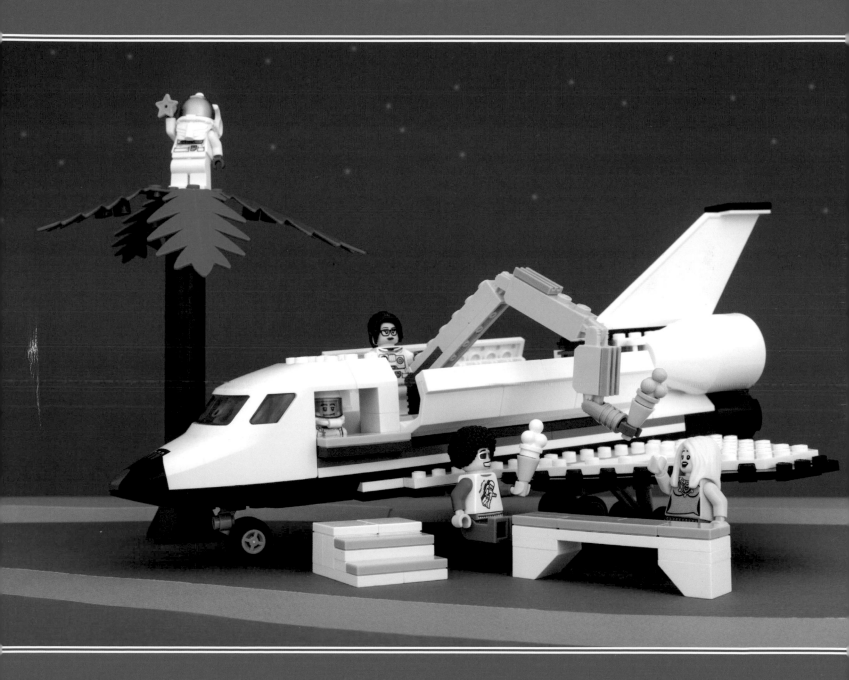

NASA is dealing with budget cuts by cashing in on astronaut ice cream's booming popularity. It's almost rocket science.

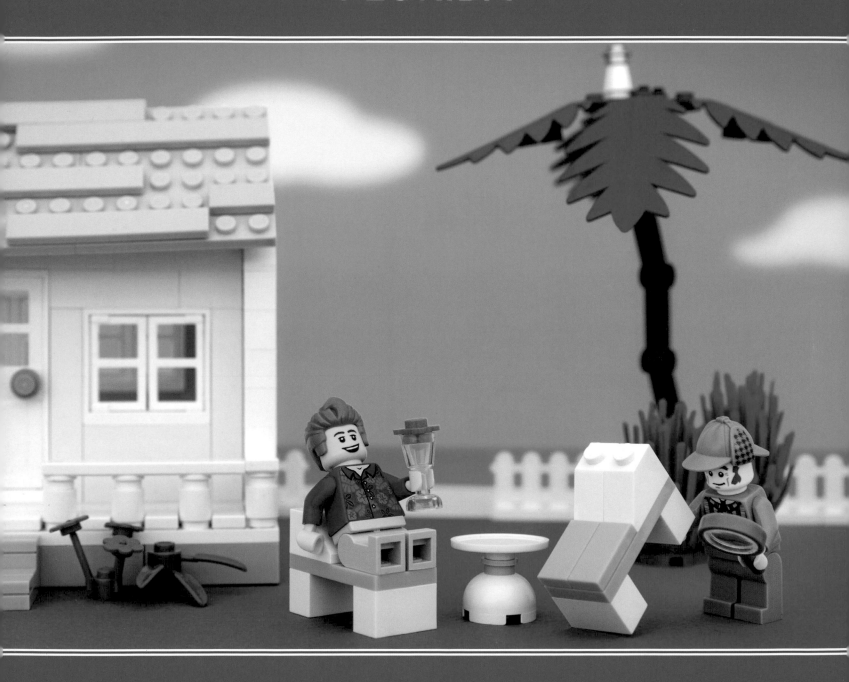

Update from Margaritaville: Still lookin' for that lost shaker of salt, now with expert help.

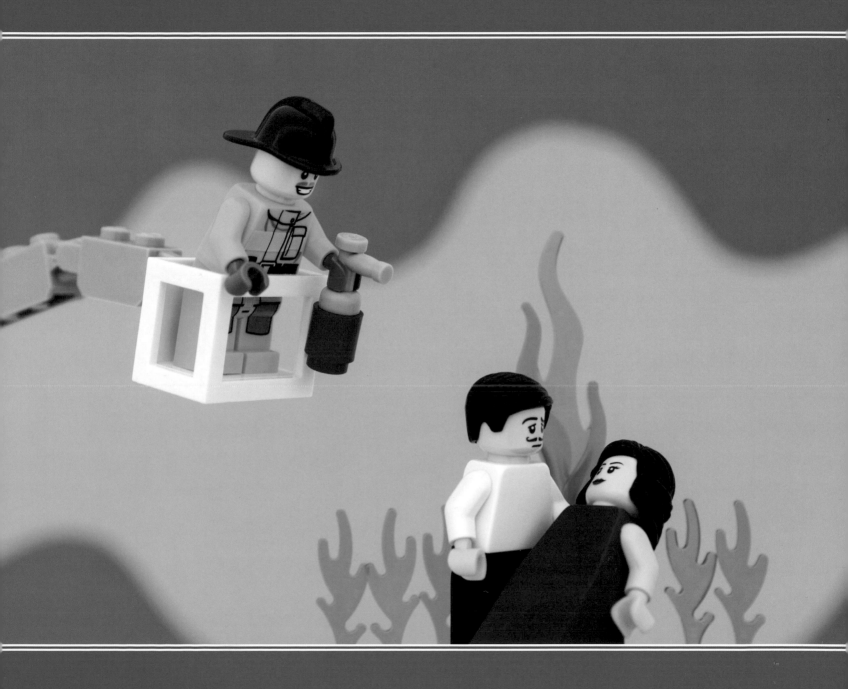

As it turns out, Rhett Butler and Scarlett O'Hara's passion for one another was easily doused by local firefighters.

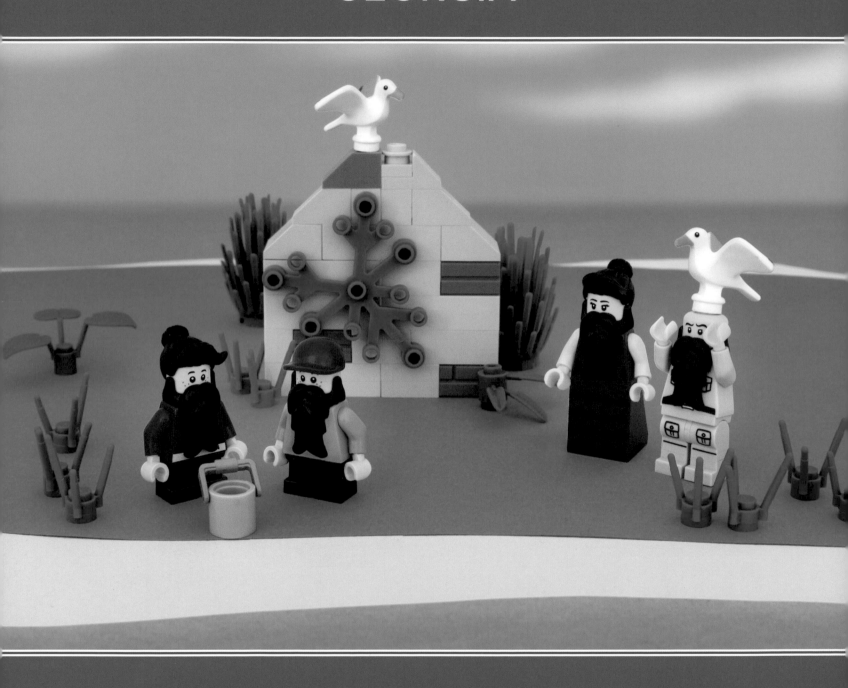

Nobody remembers how Blackbeard Island got its name.

HAWAII

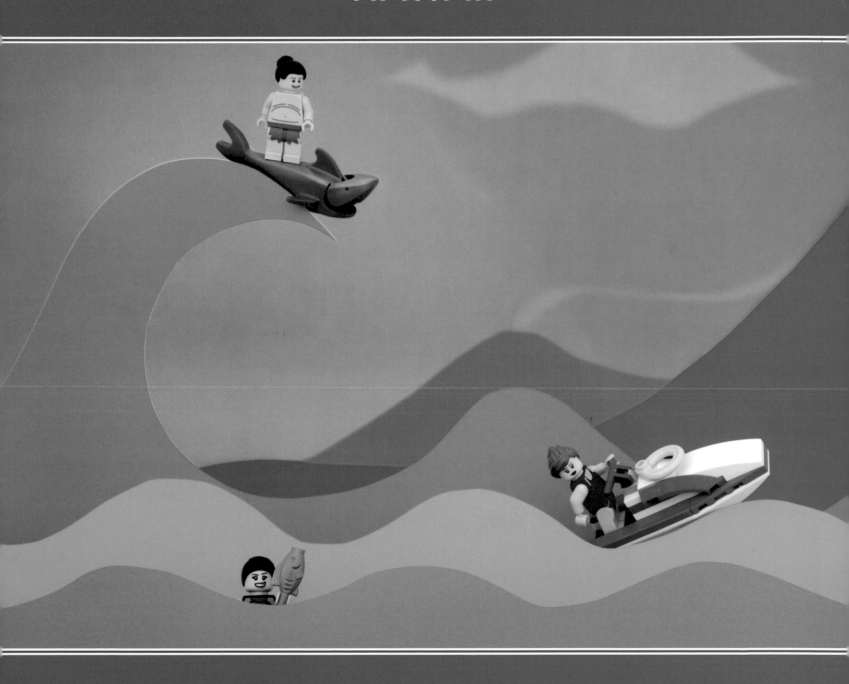

Sometimes extreme surfing is more about the board than the wave.

23

IDAHO

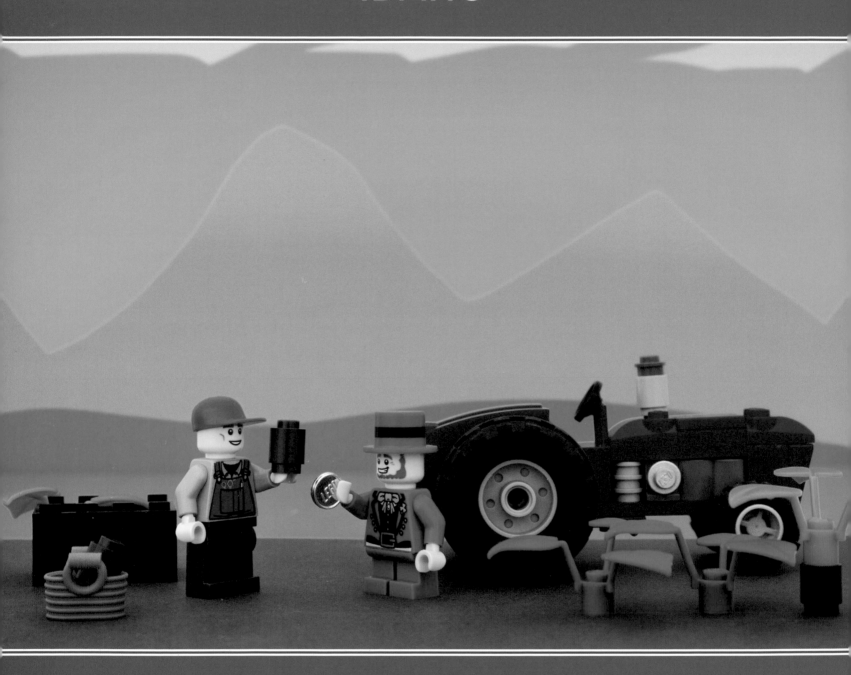

Farmer Abe is justifiably wary of little green men, but this wee fellow has big eyes for taters . . . not to mention he pays in solid gold.

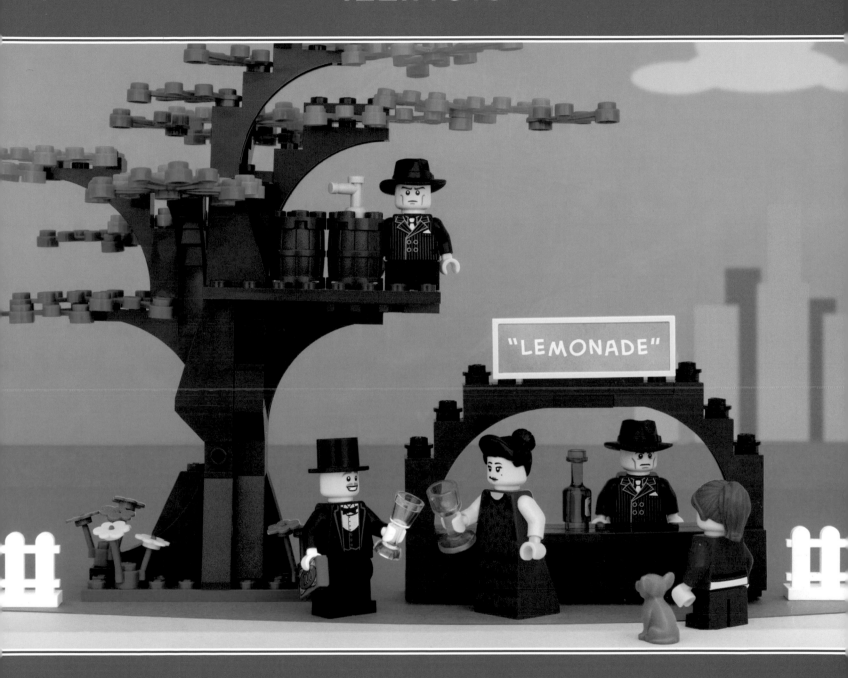

"LEMONADE"

Bugsy's mom is thrilled that he's running his own lemonade stand this summer. And to think, he hasn't rubbed out any of his playmates since June.

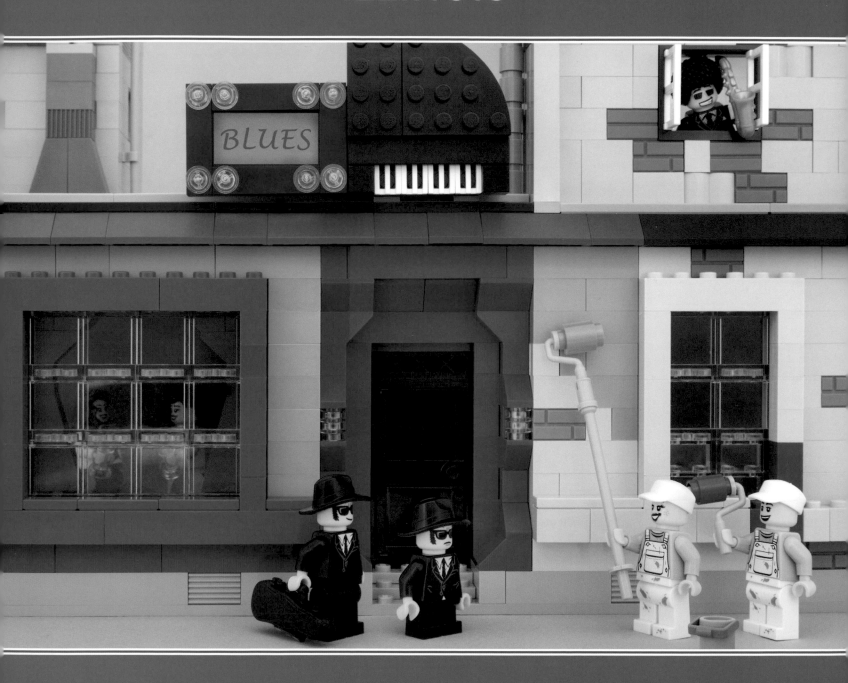

A spectrum of blues from periwinkle to Elwood.

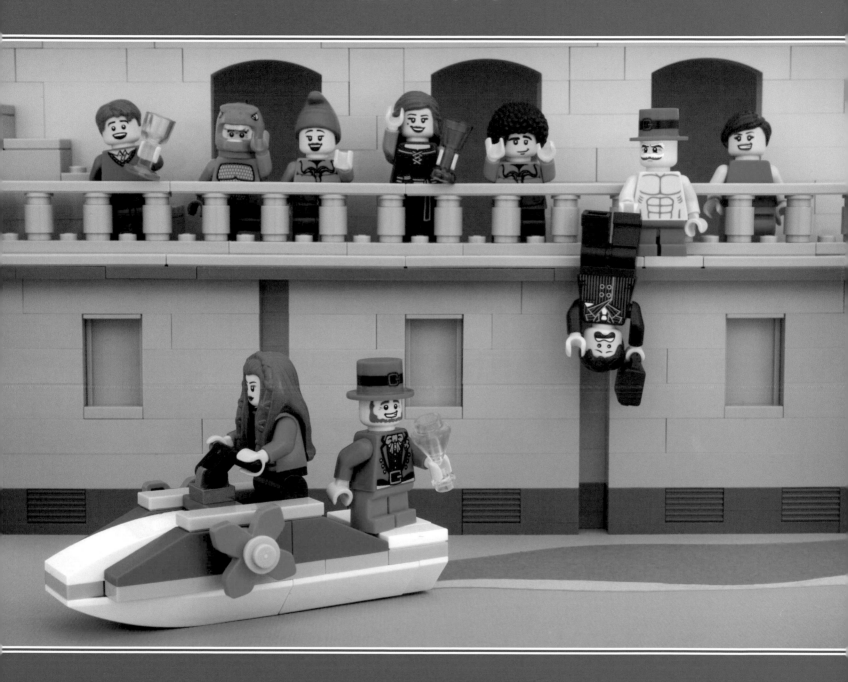

Chicago is a world leader in green energy.

INDIANA

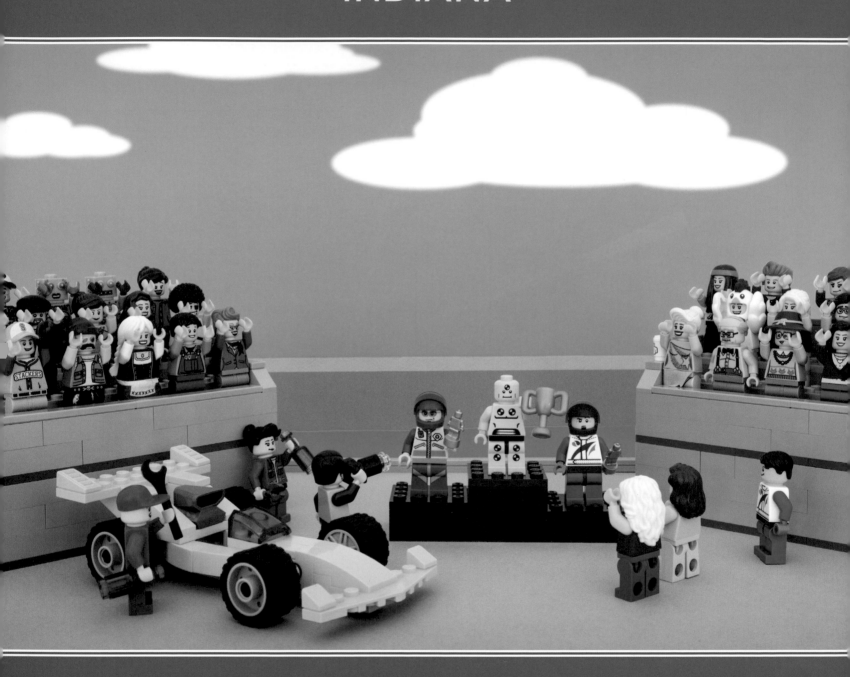

After bouncing back from harrowing crashes all season, an unknown racer won the Indy 500 by driving as if he had nothing to lose.

INDIANA

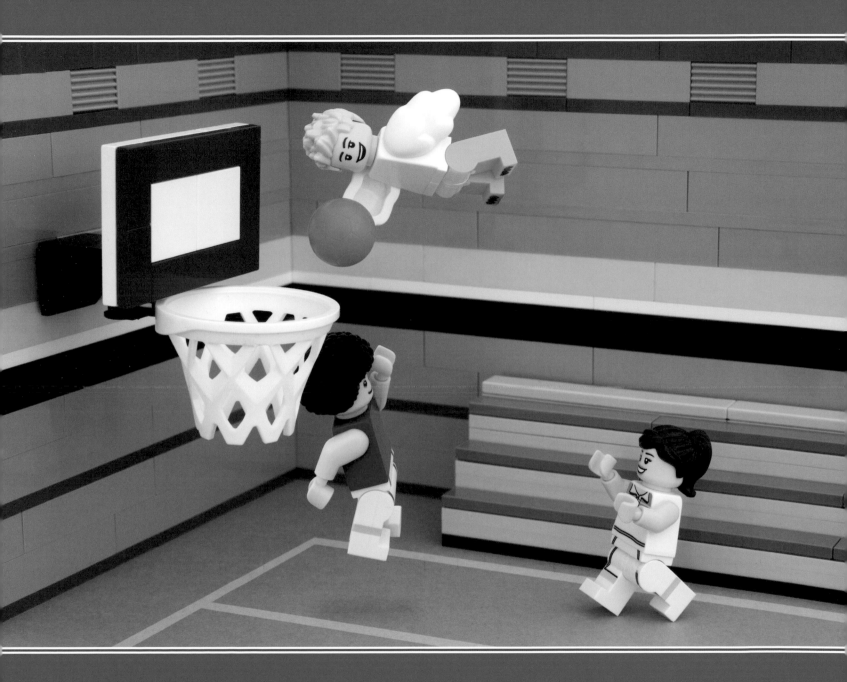

When in doubt, pass to Larry Bird. He's the ultimate wingman.

IOWA

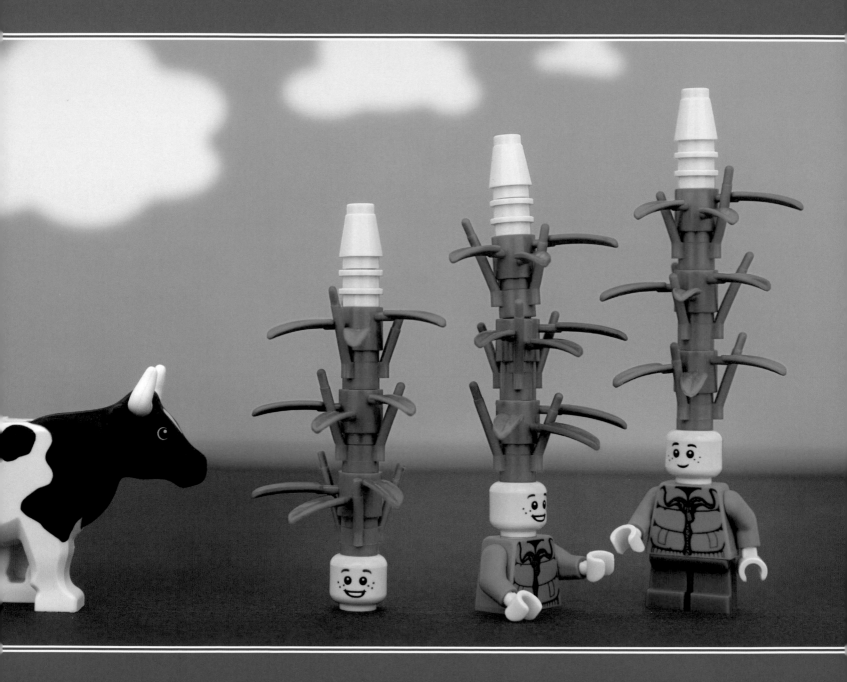

Every summer you see them emerging bright yellow from their green jackets: the children of the corn.

IOWA

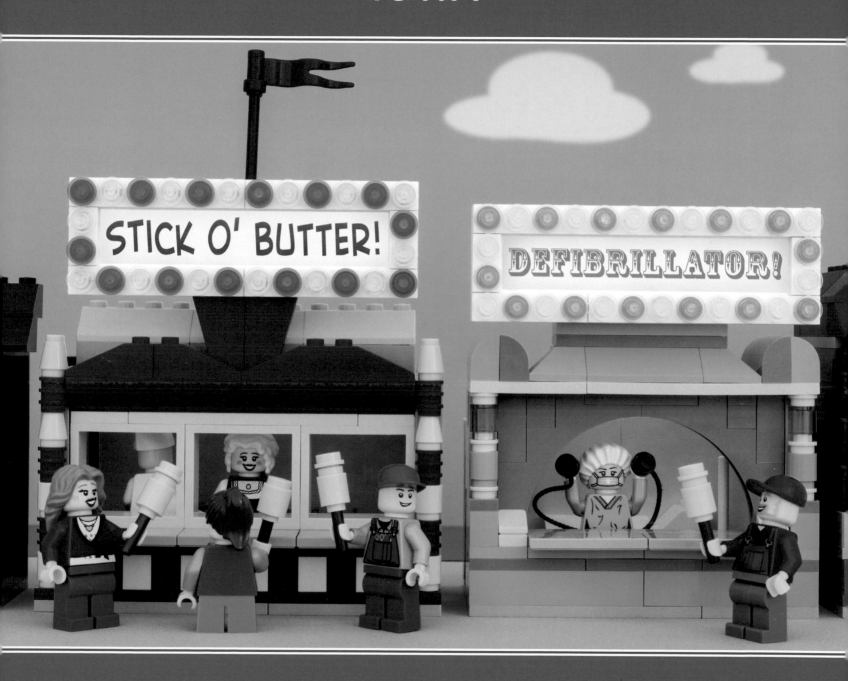

Carnival doctors provide a much-needed jolt at the Iowa State Fair.

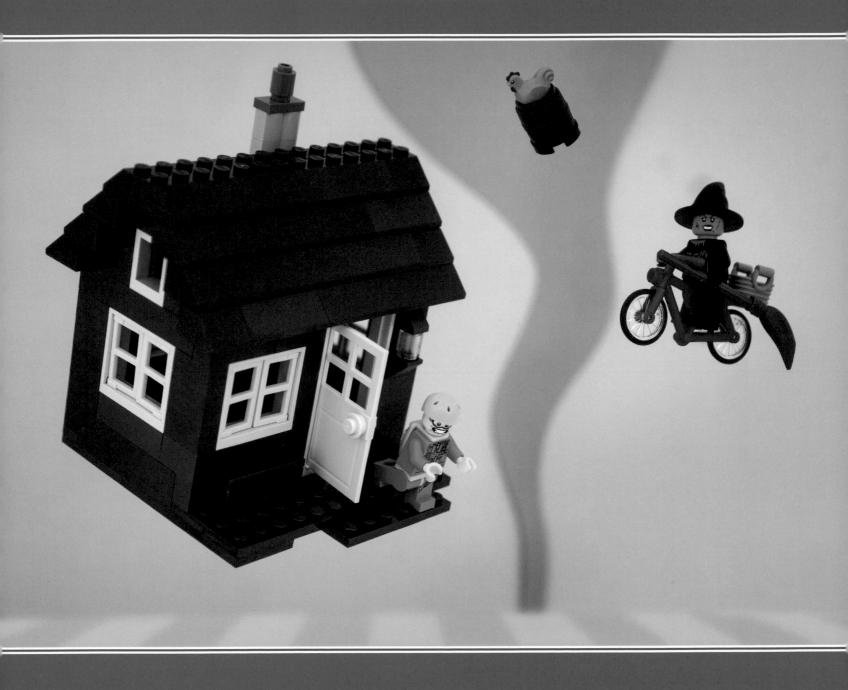

There's no place like home, but if your house is frequently blown aloft, it helps to wear a parachute indoors.

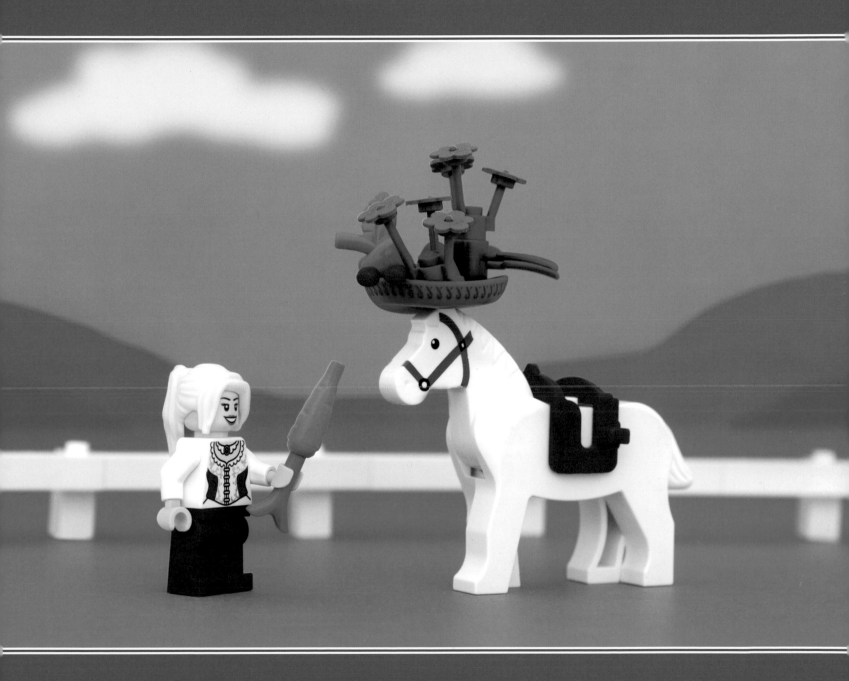

Brave belles explore the outer reaches of the Kentucky Derby hat.

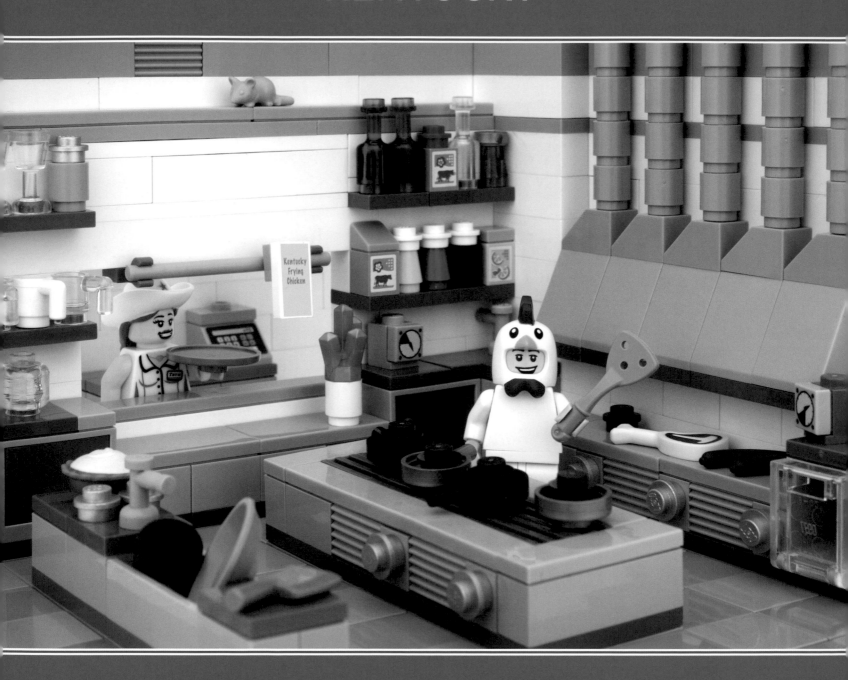

What came first, the chicken-fried steak
or the Kentucky Frying Chicken?

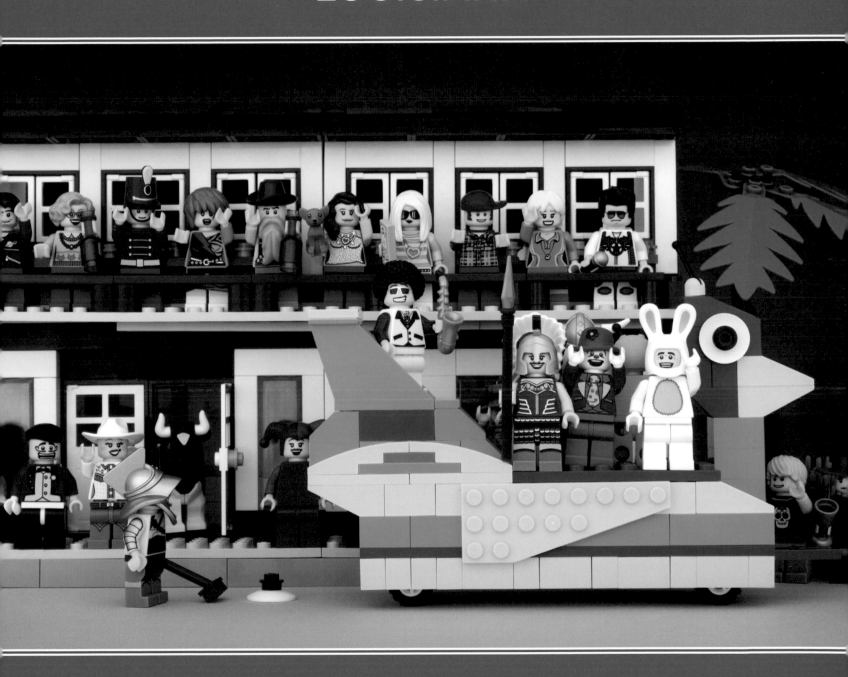

A Mardi Gras float is only as good as its cleanup crew.

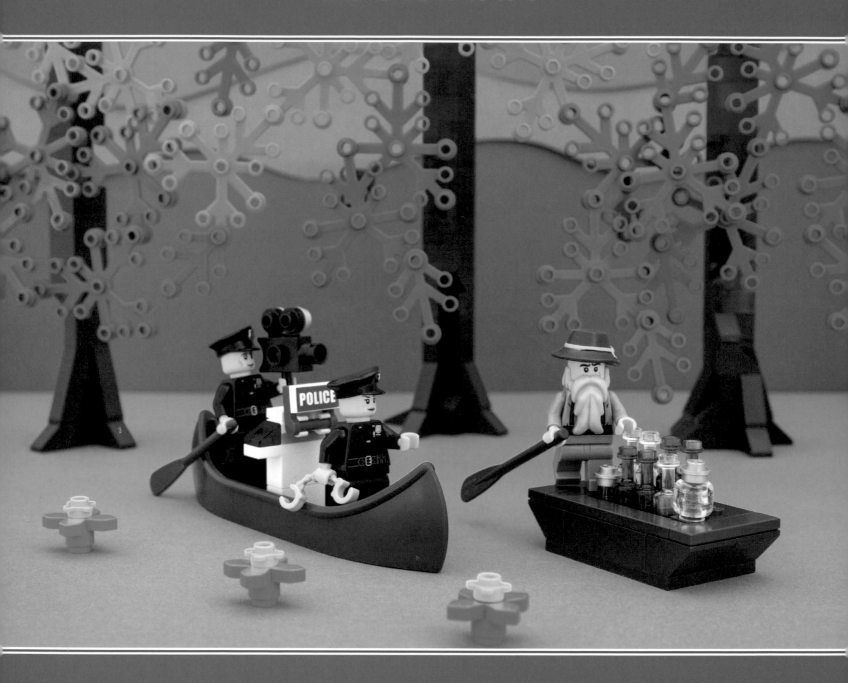

Be sure to catch this week's episode of *The Bayou's Best Slow-Speed Chases*!

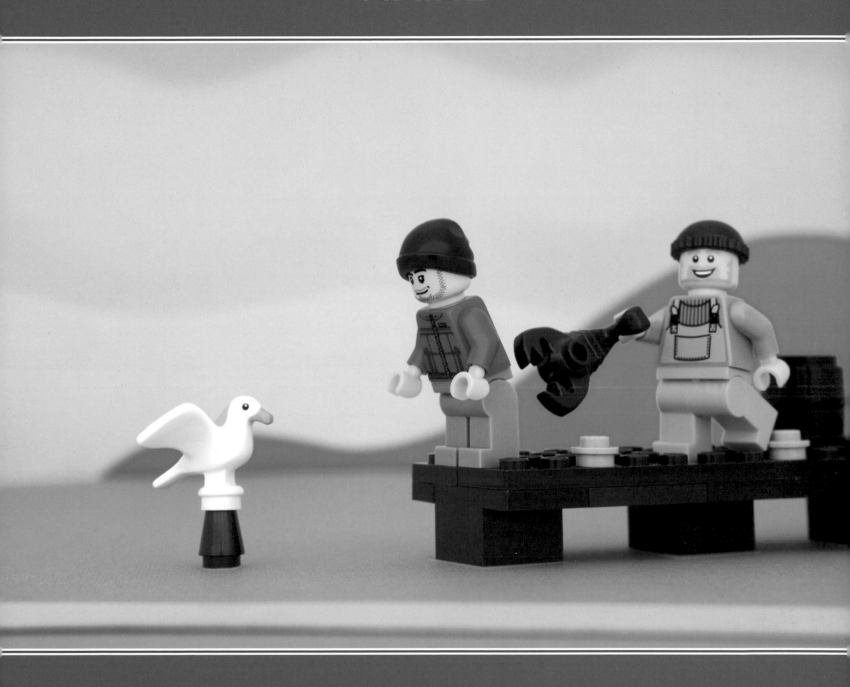

If you find yourself in a pinch, just rub the swollen area with Moxie.

MAINE

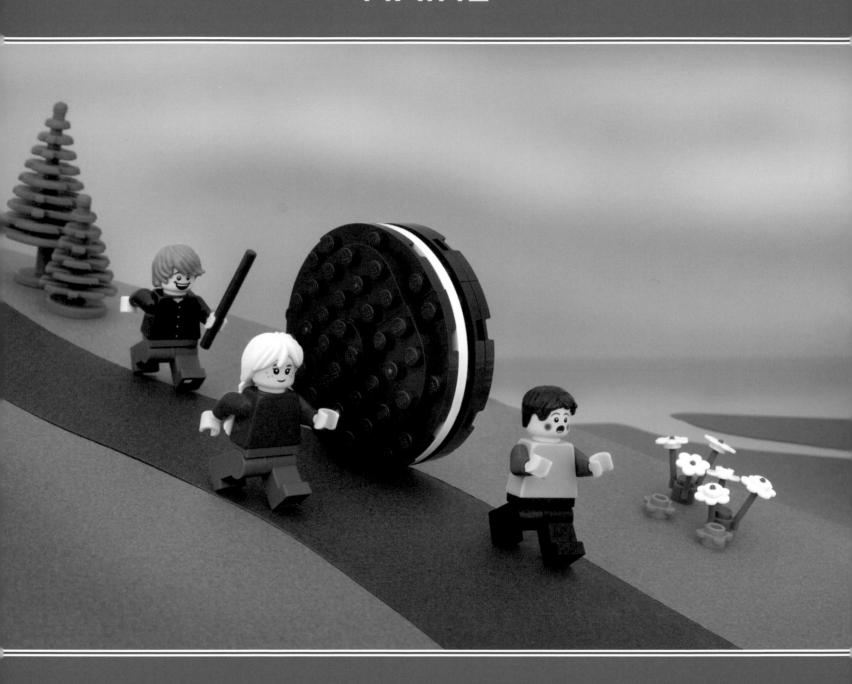

Maine kids celebrate spring with the traditional rolling of the giant whoopie pie.

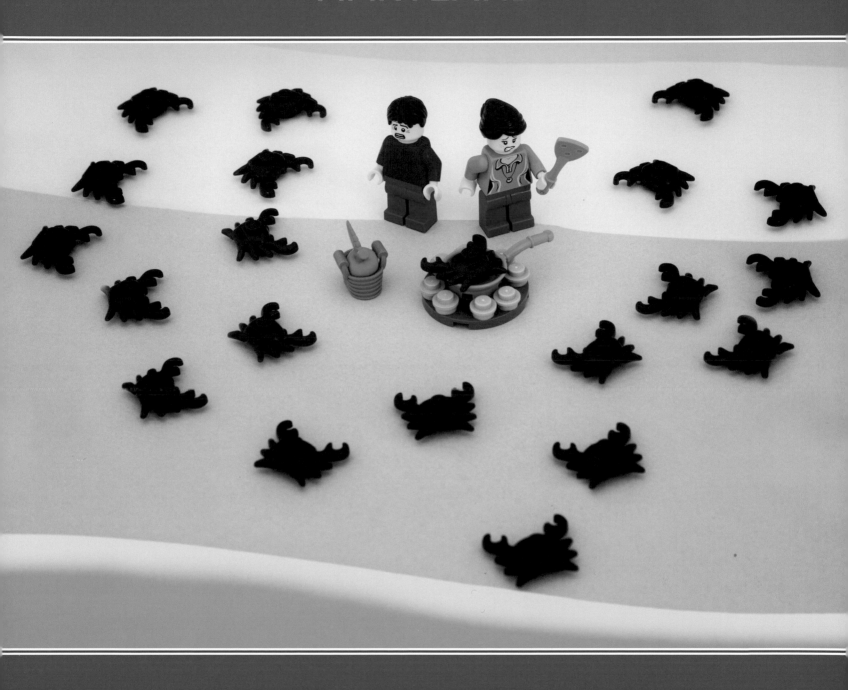

Today the crabs decided to have a picnic of their own.

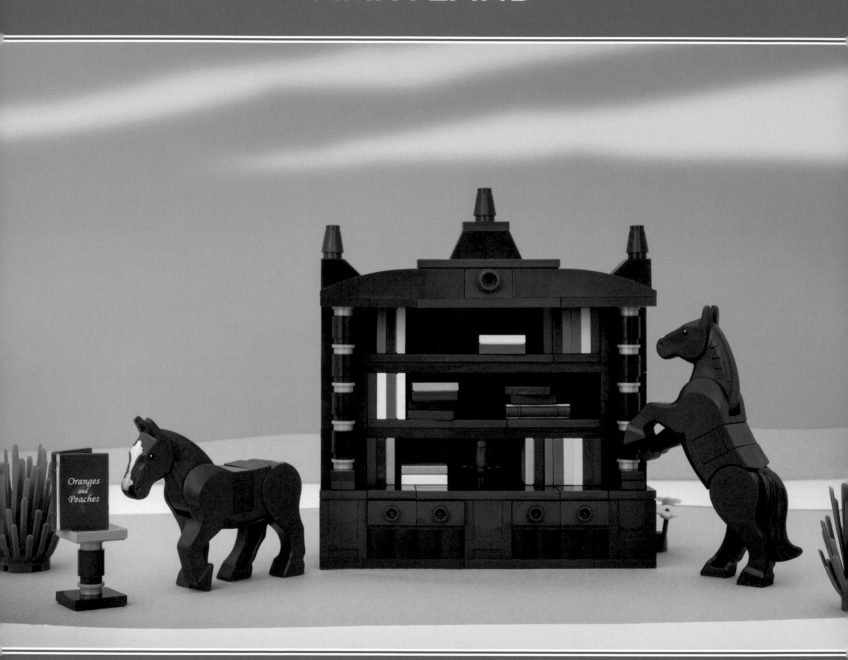

Oranges and Peaches

Assateague Island's wild horses are so untamed they brazenly eschew Library of Congress Classification when organizing bookshelves.

MASSACHUSETTS

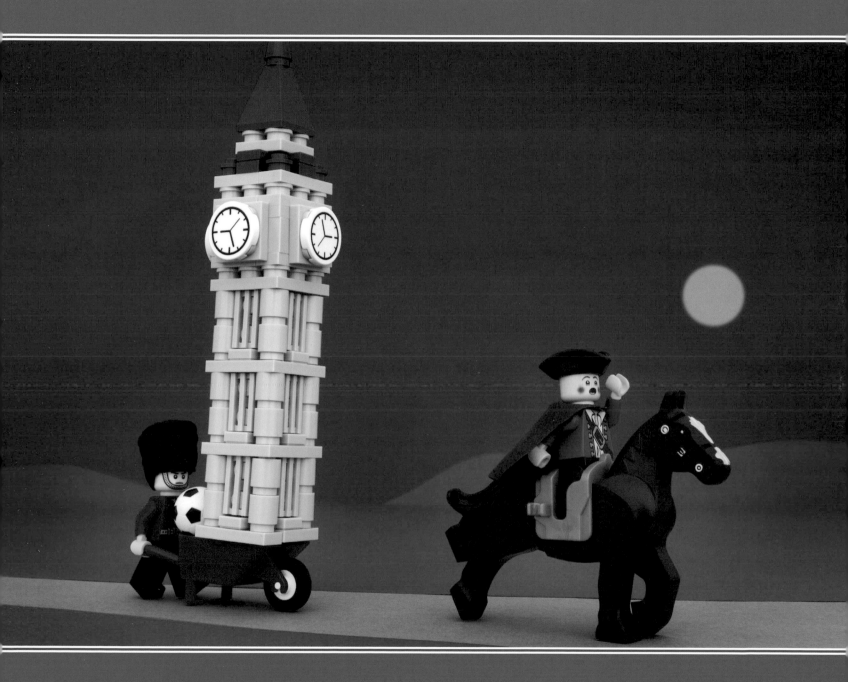

The British are coming! How Paul Revere figured it out is anyone's guess.

MASSACHUSETTS

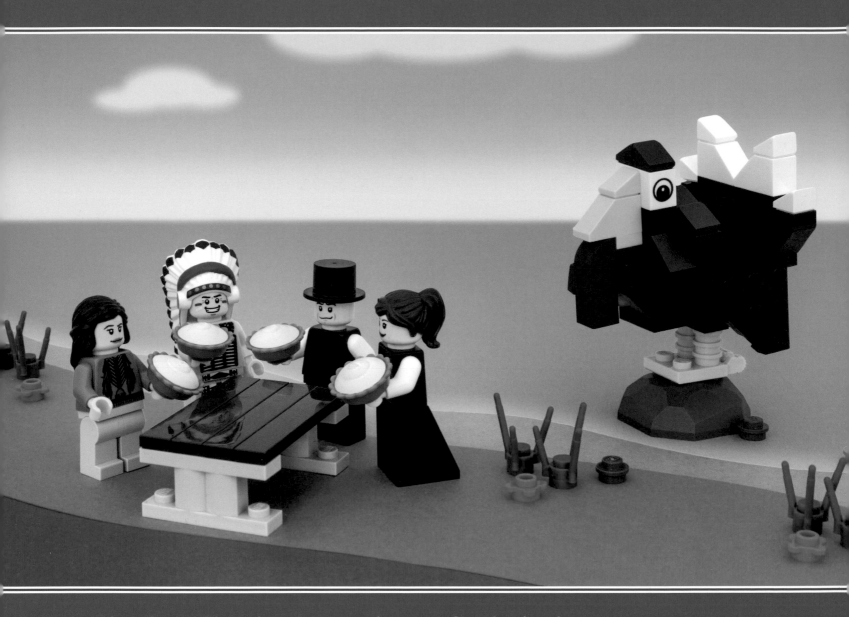

The first Thanksgiving almost fizzled when every guest showed up with dessert. By lucky chance, the idea for a main course presented itself when a giant turkey alighted on Plymouth Rock. Half-witted but full-flavored, the buttery birds were soon hunted to extinction.

MASSACHUSETTS

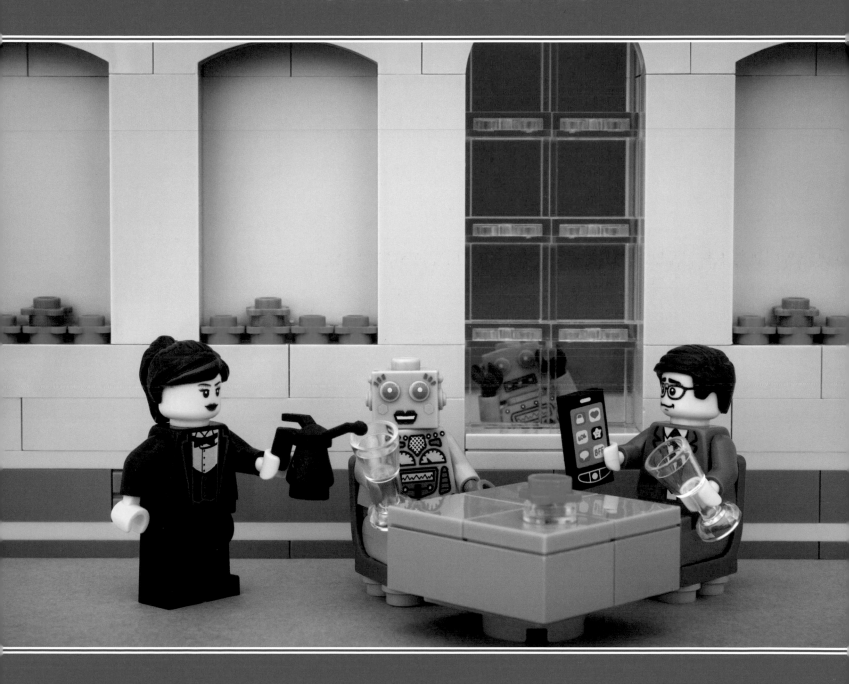

Even the biggest nerds can find a date at MIT. (In case you're looking, there's a hidden stash of them in the robotics lab basement.)

MICHIGAN

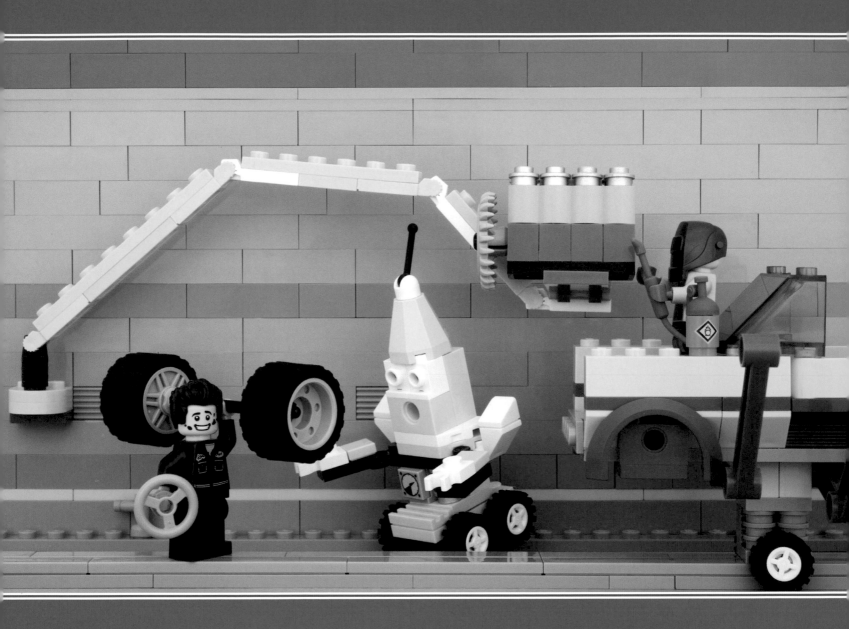

Machines will never replace humans in manufacturing or caption writing. Ha!
—This automated caption generated by Dumbchuckle Software's Groaner 5.1

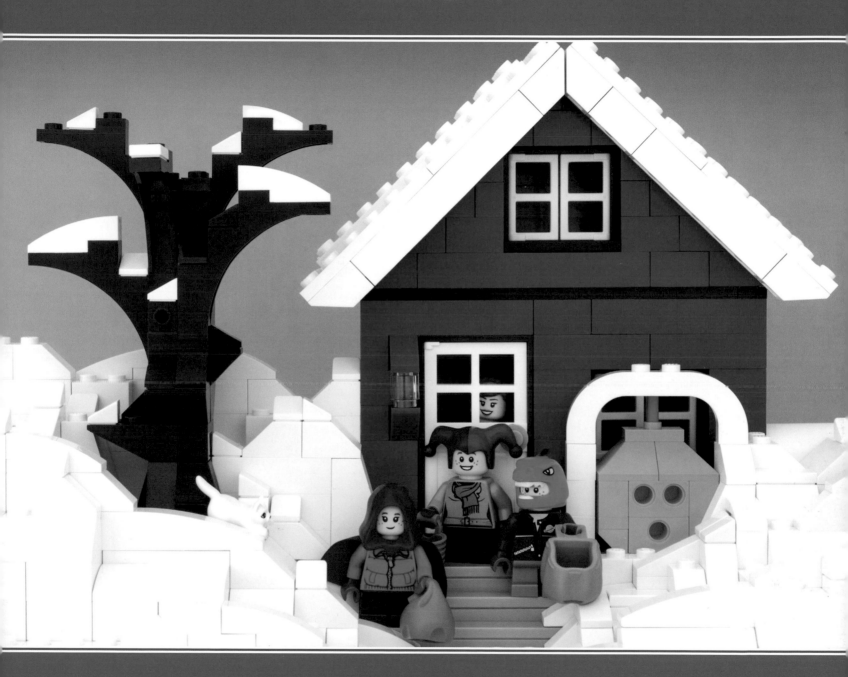

'Twas the snowstorm before Halloween.

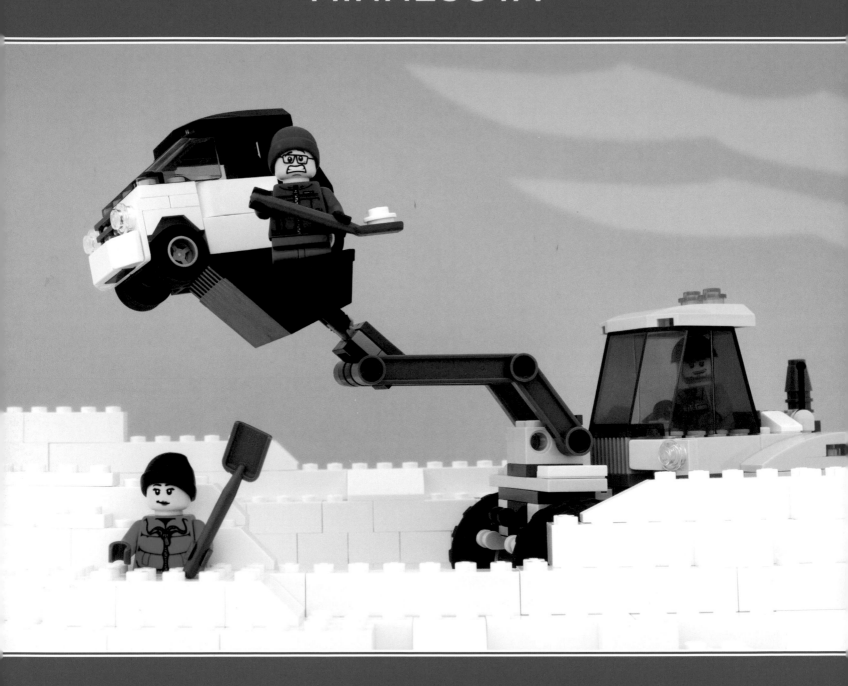

Some places have a dry cold. In Minnesota it's a nice cold, okey-dokey?

MINNESOTA

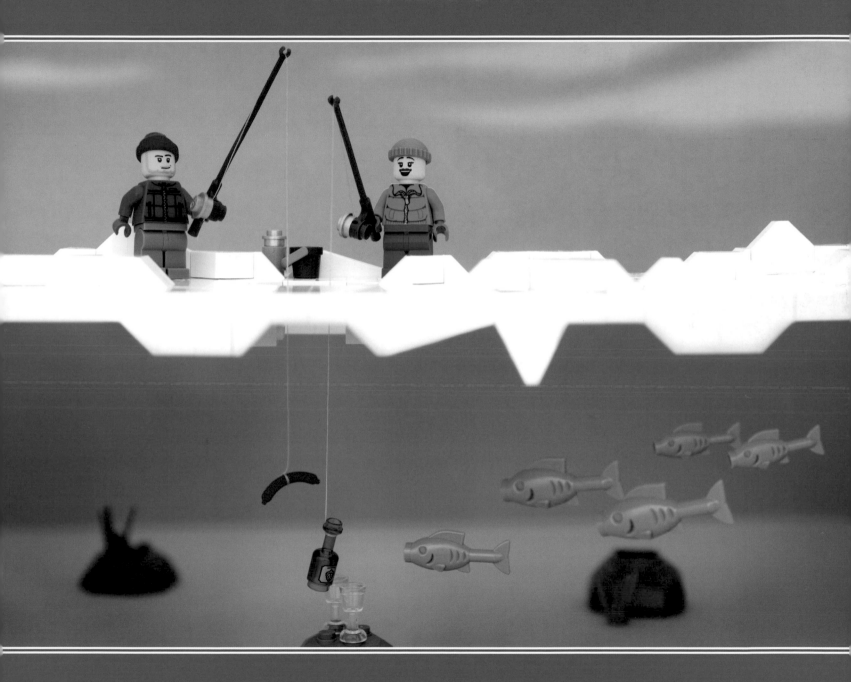

Savvy anglers know that today's sophisticated walleyes refuse bratwurst bait unless it's paired with a medium dry Riesling.

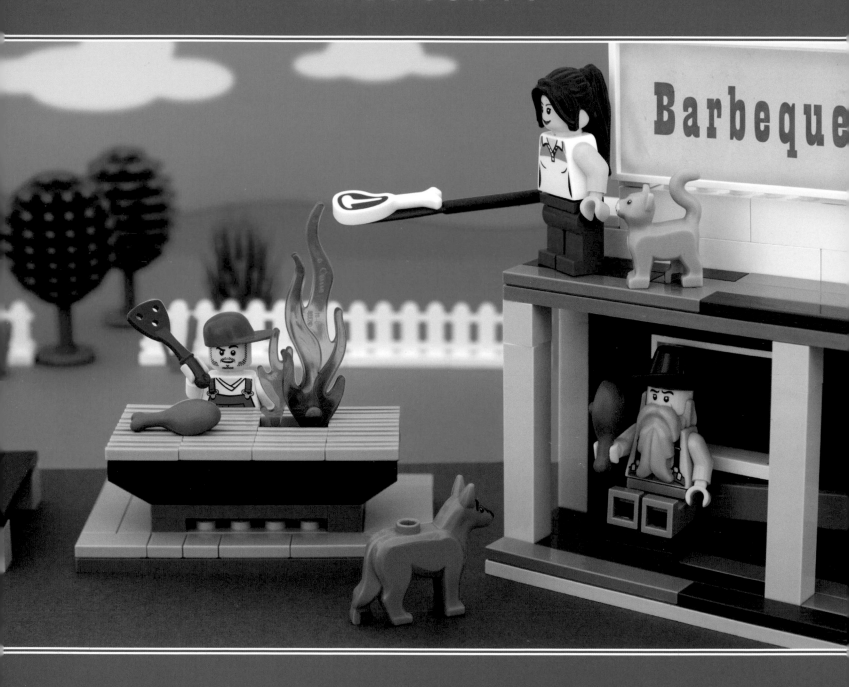

Slow-cooked meat that's finer than frog's hair and tenderer than toad love.

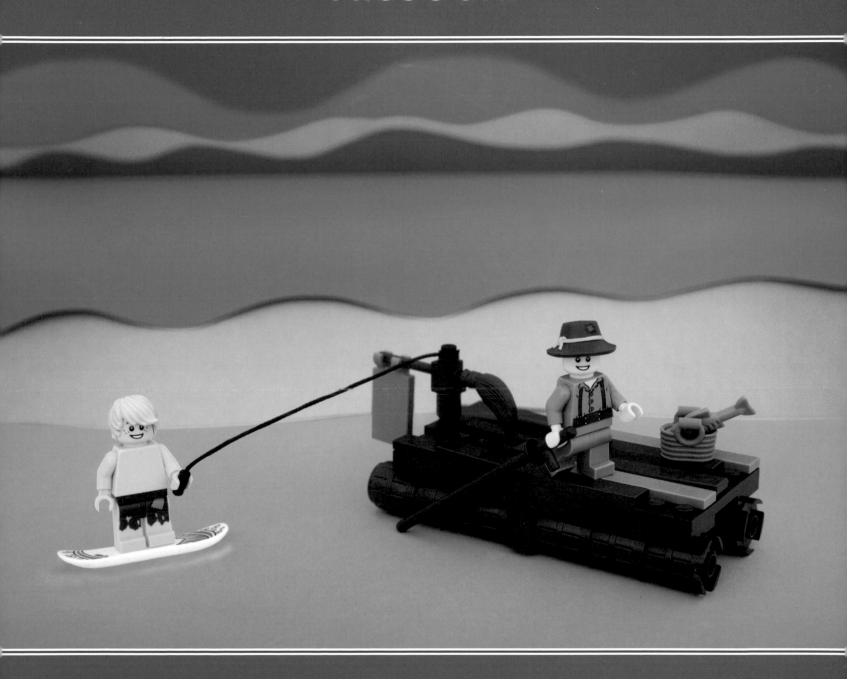

The wakeboarding scenes were edited out of Mark Twain's books for brevity.

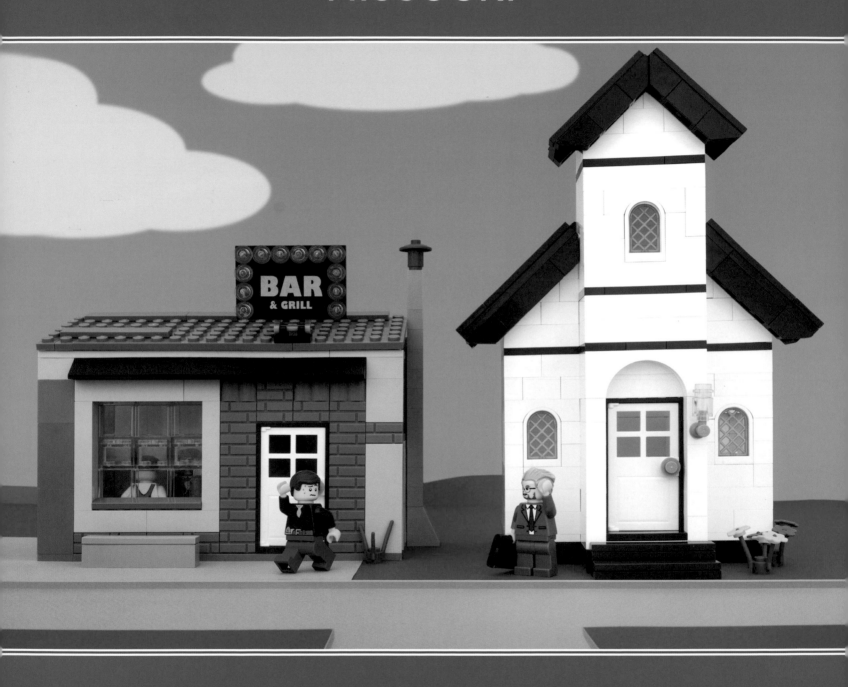

Hazardous heartland intersections.

MONTANA

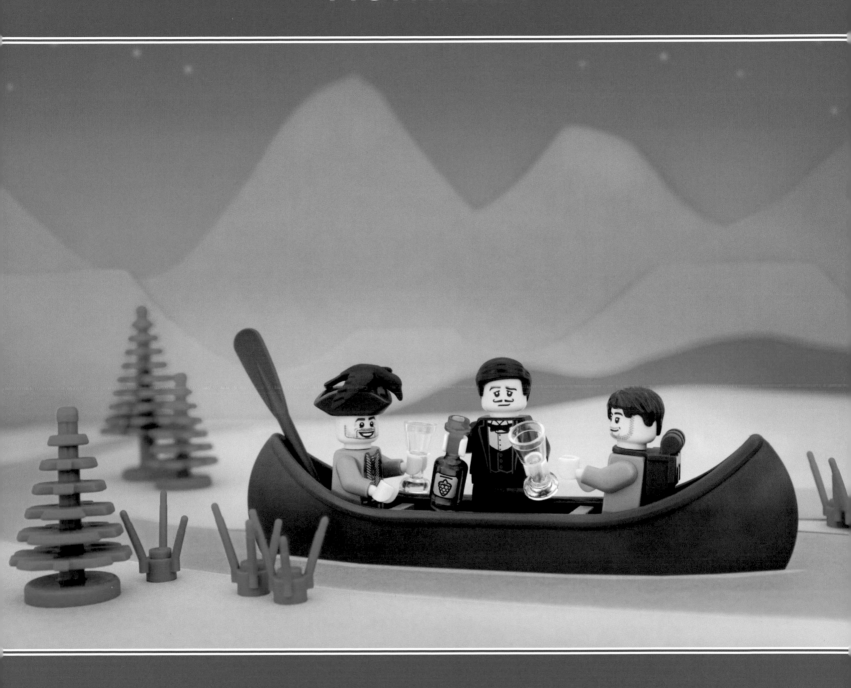

Curiously absent from Lewis and Clark's journals is Gaston, their faithful manservant.

NEBRASKA

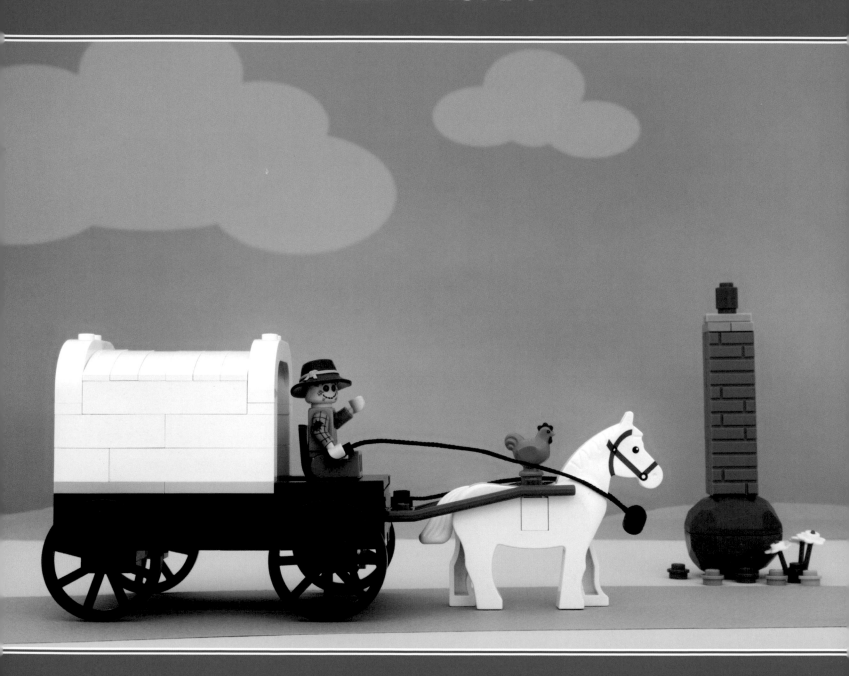

Chimney Rock has to be around here somewhere.

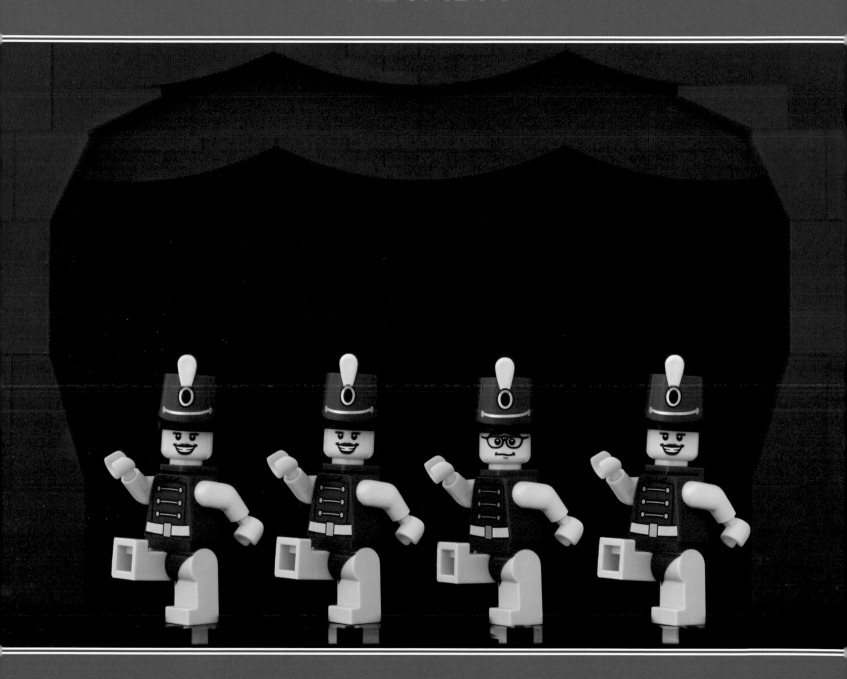

What happens in Vegas stays in Vegas, hopes Gilbert, who rarely stage-crashes showgirl performances back in Des Moines.

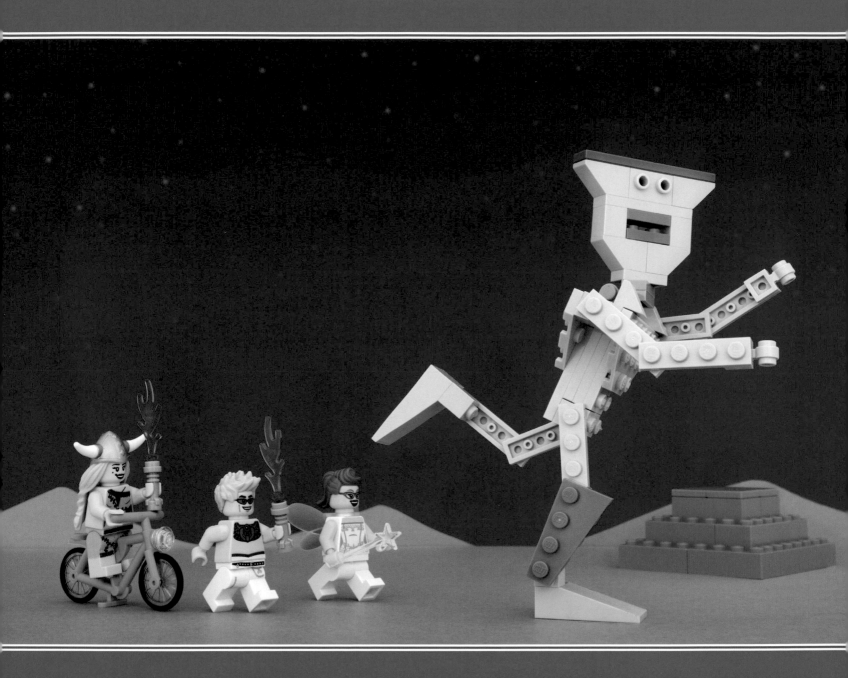

Being named the Burning Man comes with a particular set of problems.

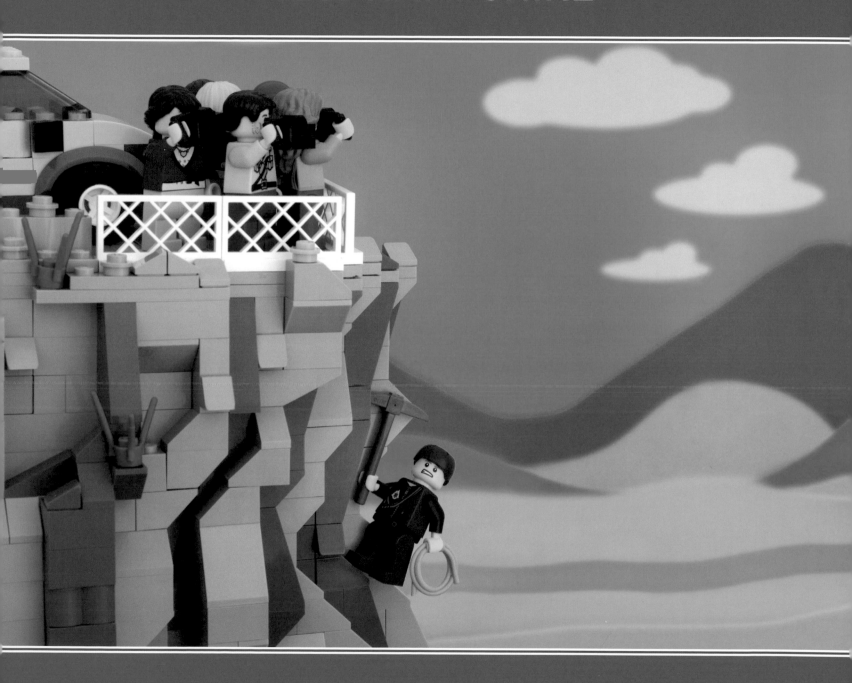

Robert enjoys climbing in the White Mountains for the solitude that only untouched wilderness provides.

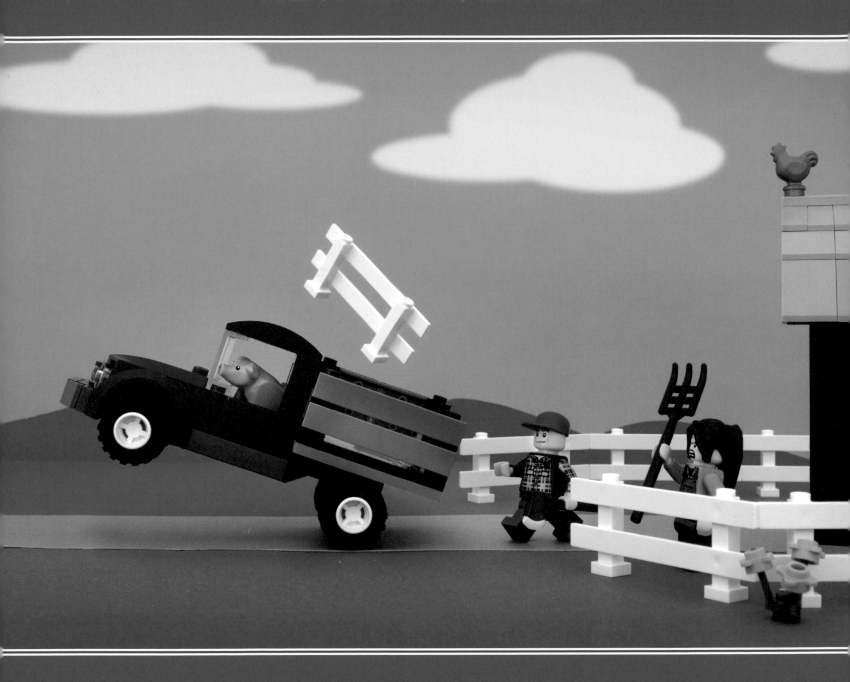

Mr. Sizzles was inspired to make his move after reading the farm truck's license plate slogan: Live Free or Die!

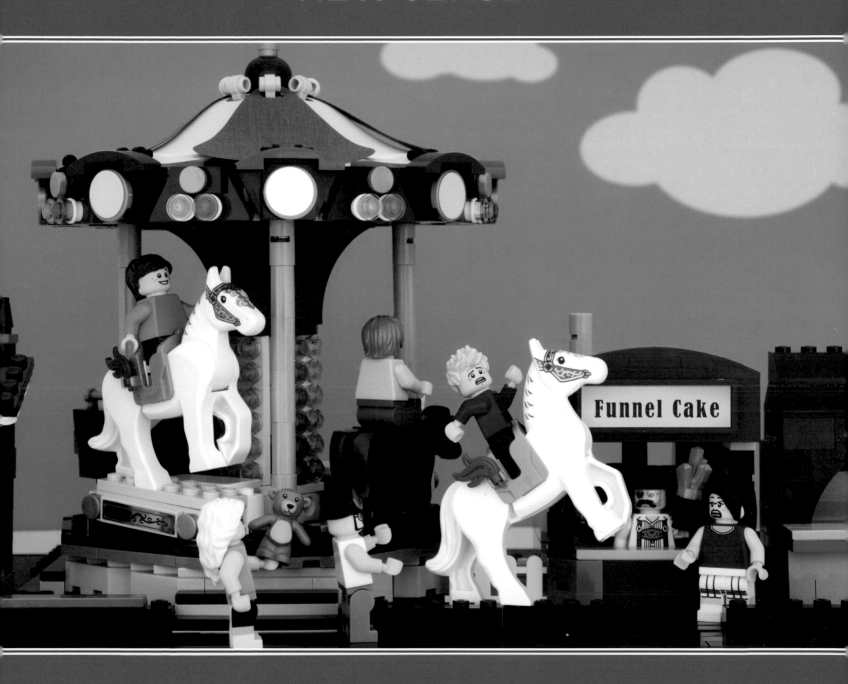

Dreams come to life on the Jersey shore—and some nightmares as well.

NEW JERSEY

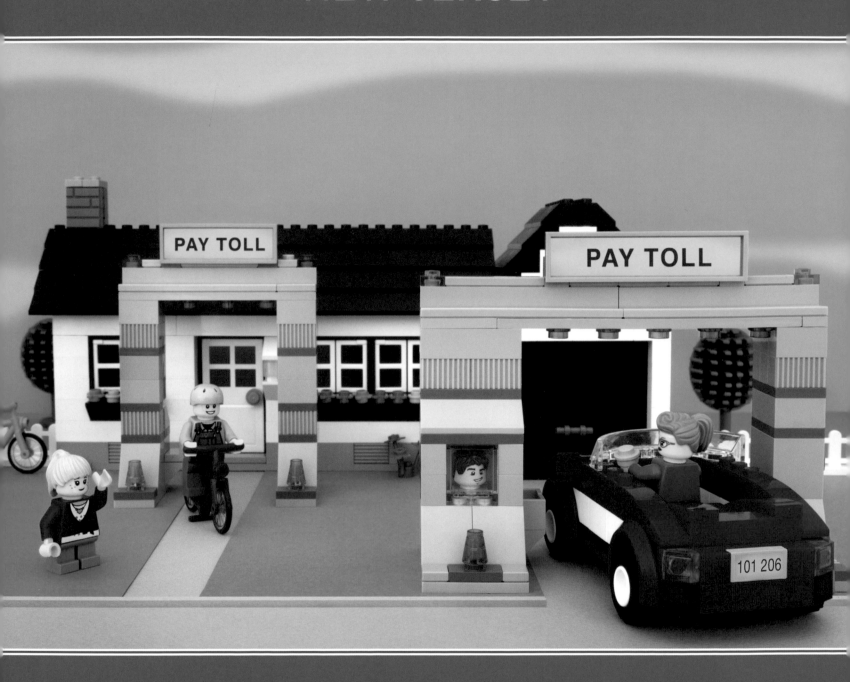

PAY TOLL

PAY TOLL

101 206

Turnpike life takes its toll.

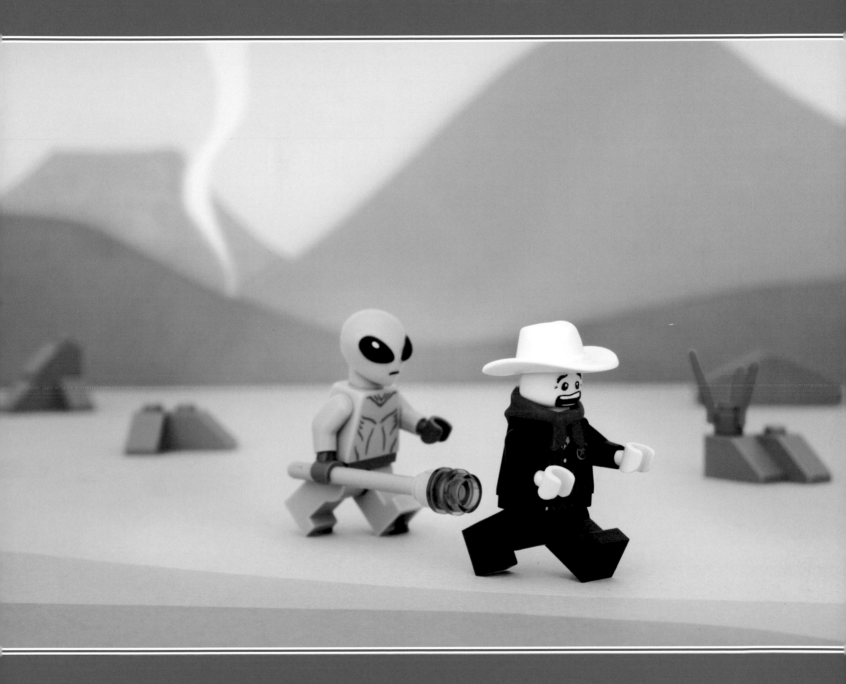

People tend to shy away from probing questions in the Land of Enchantment.

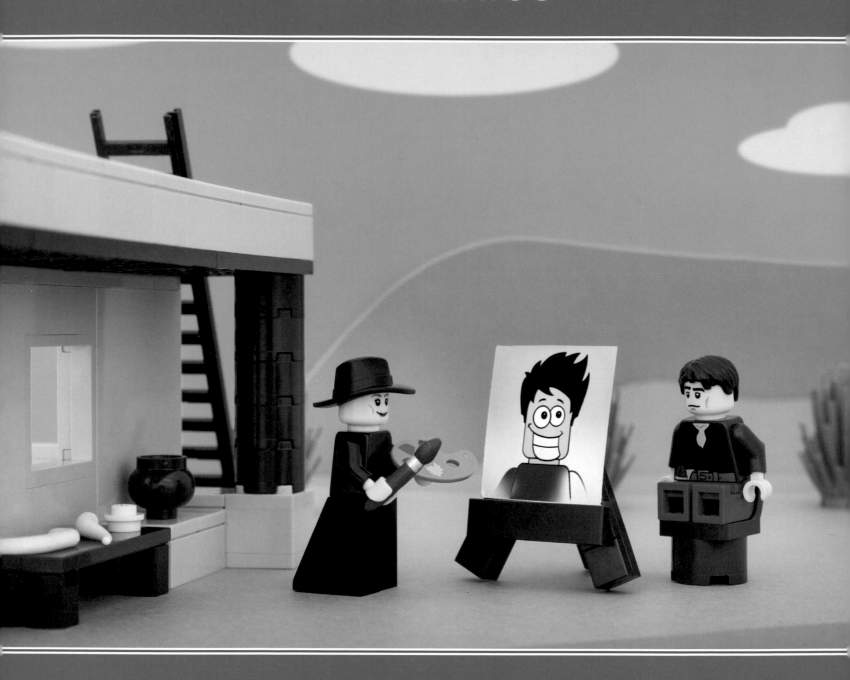

The art world remains in denial about Georgia O'Keeffe's wacky cartoon portrait phase.

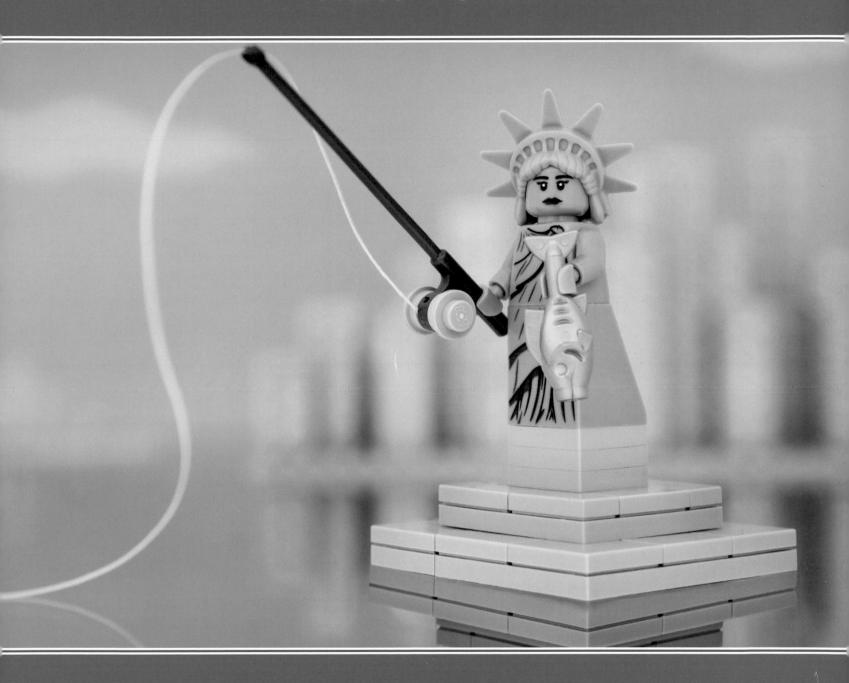

Give me your tired, your poor, your creamy masses
of tartar sauce.

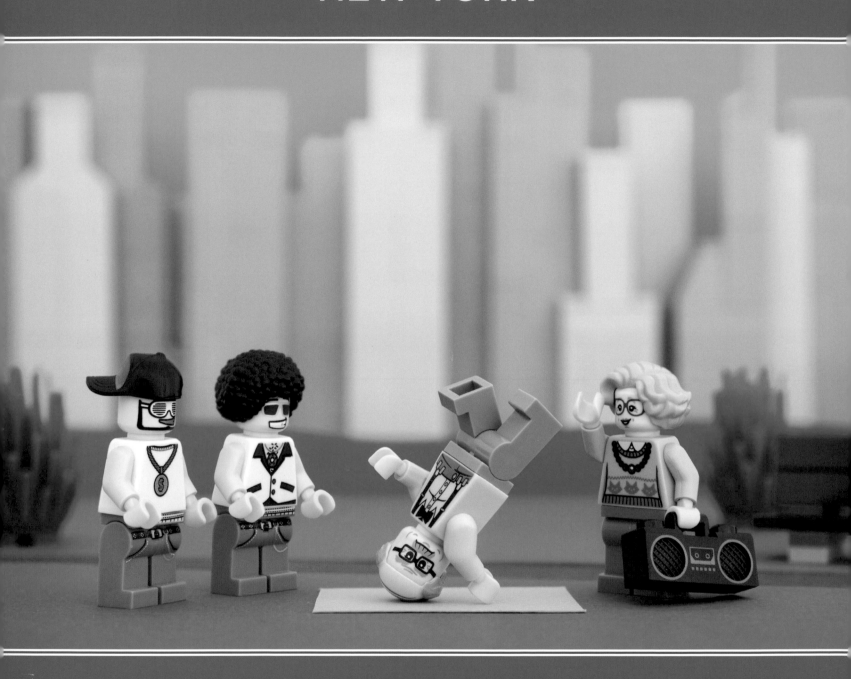

When the ambulance arrived, Frank was still locked in mid-windmill position.

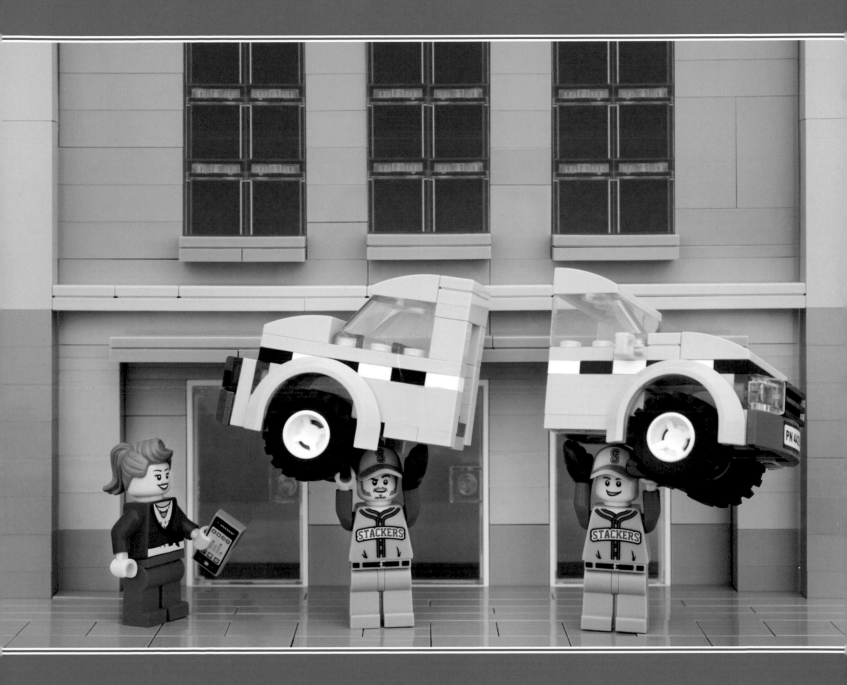

Just a couple of regular joes, these farm-team players
split a cab to Yankee Stadium.

NORTH CAROLINA

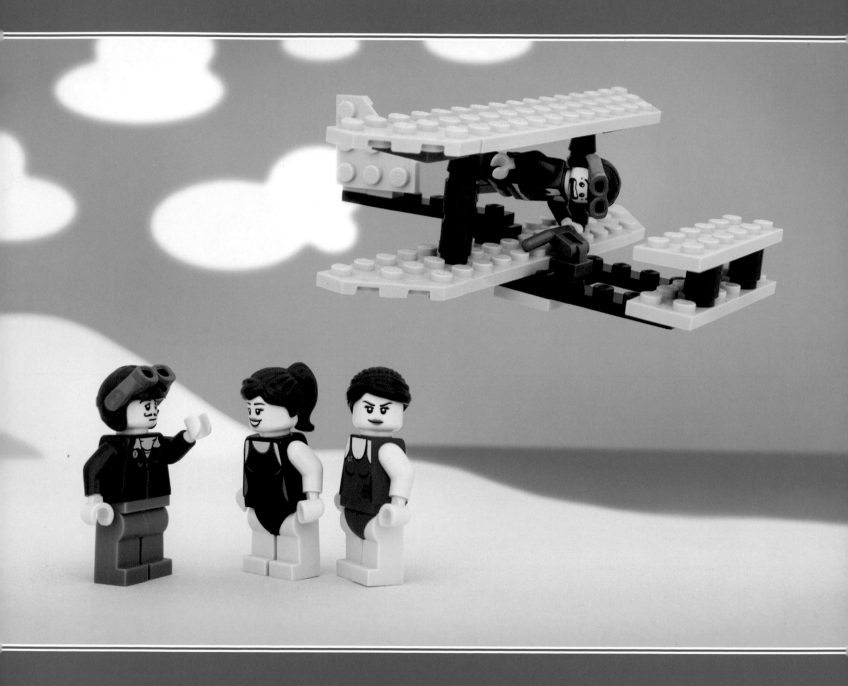

The truth is that while Wilbur did most of the flying, Orville had other interests at the Kitty Hawk beach.

NORTH CAROLINA

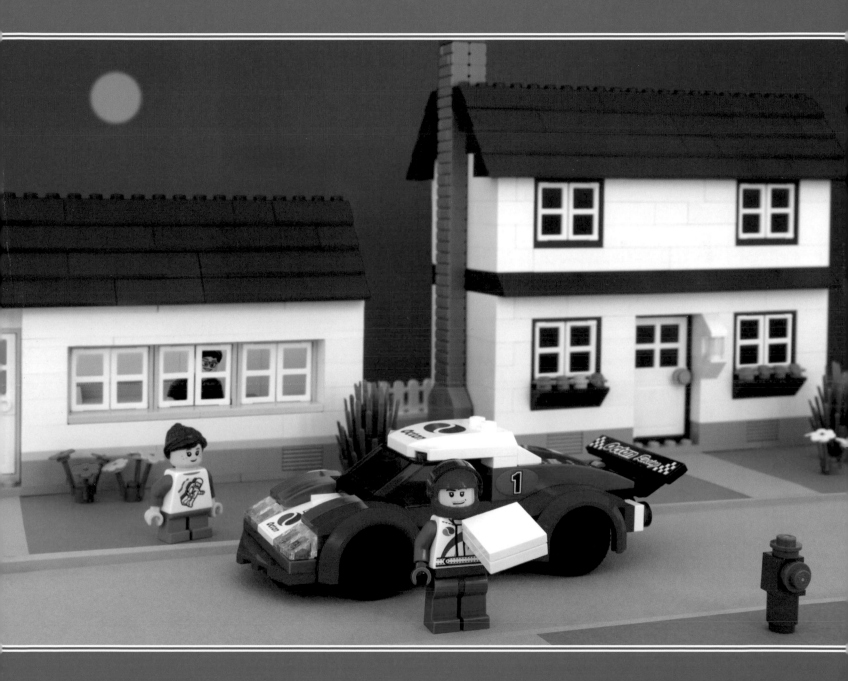

Enterprising NASCAR drivers earn extra spending money by delivering pizzas during the off-season.

NORTH DAKOTA

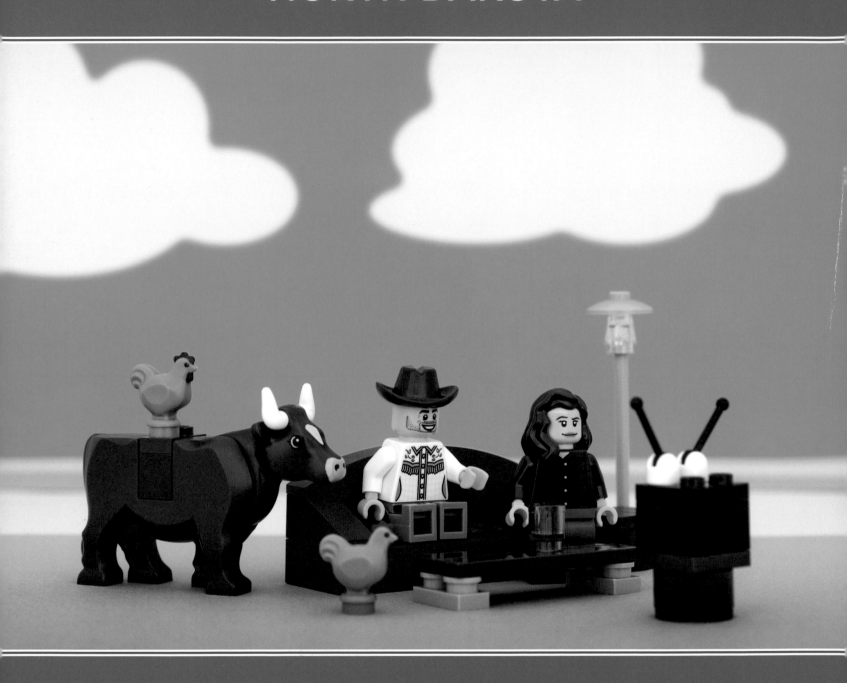

Home, home on the range, where the reruns of *Three's Company* play.

OHIO

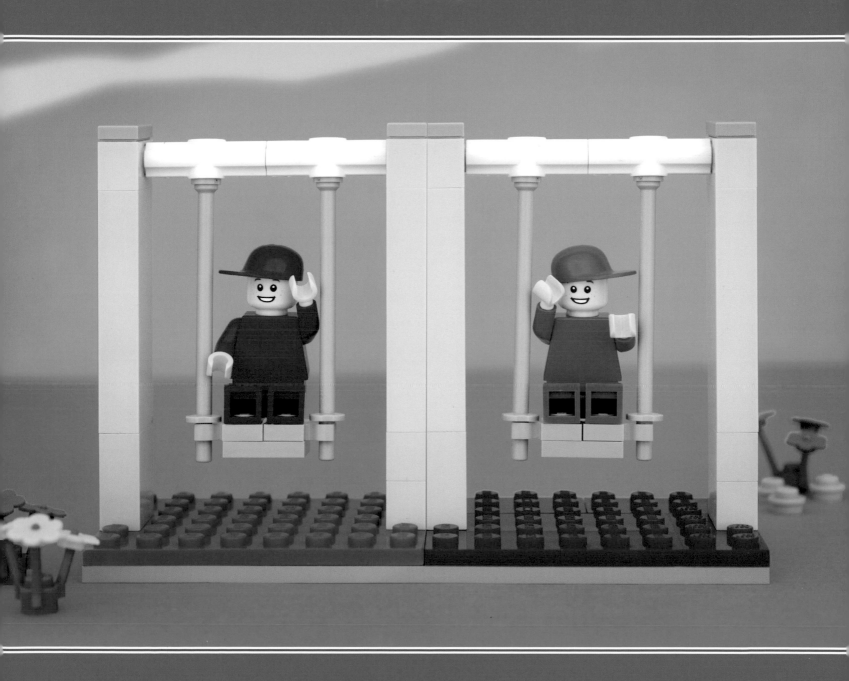

Ohio puzzles presidential candidates, but kids love living in a swing state.

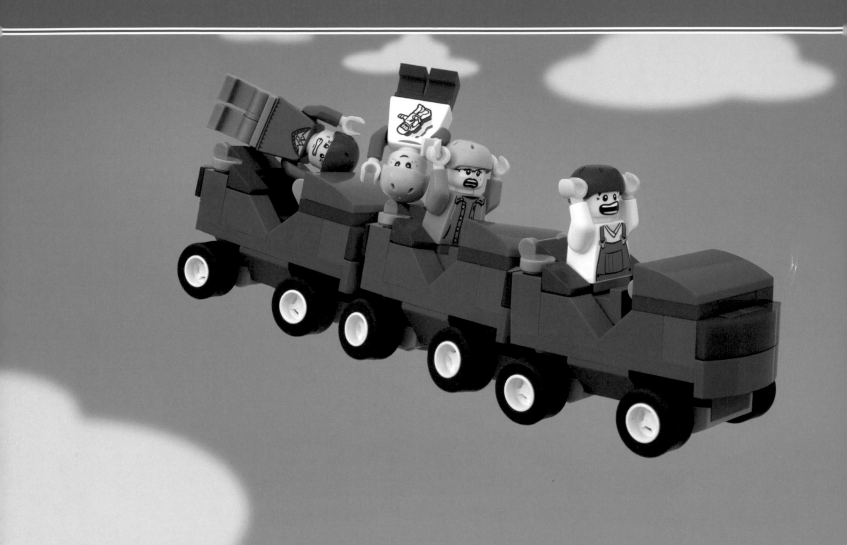

Cedar Point's new extreme roller coaster, the Chagrin Falls, is launched from the back of a transport plane for a thrilling 17 seconds of free fall.

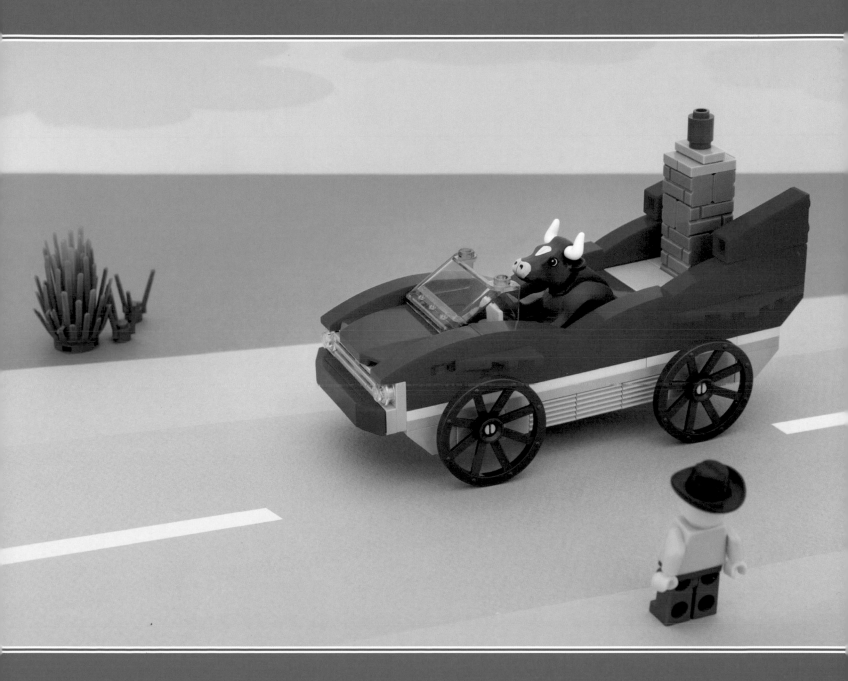

Home to famous cattle drives.
Tailgate their methane-powered rides at your own peril.

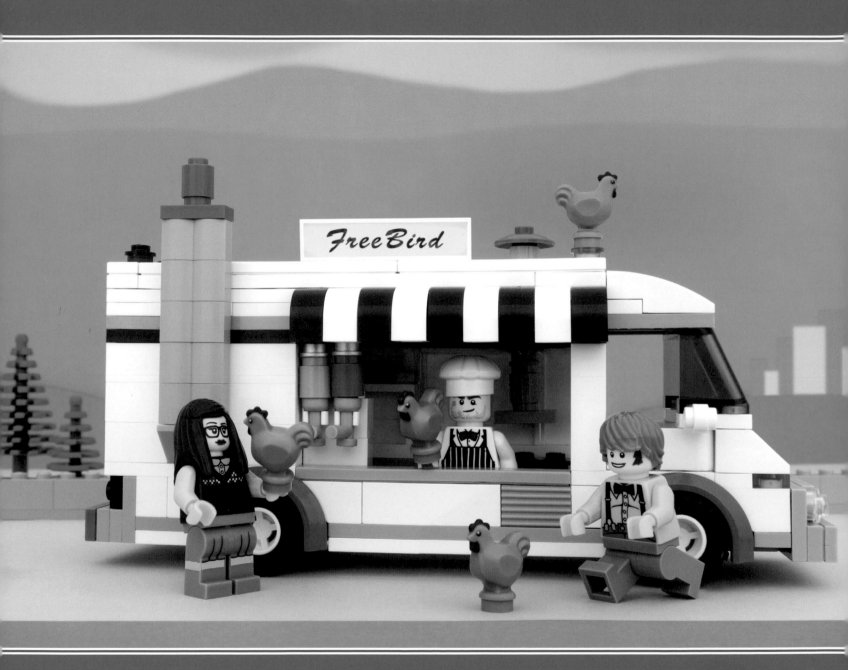

Free-range chickens flee gluten-free hipsters at the
FreeBird food truck.

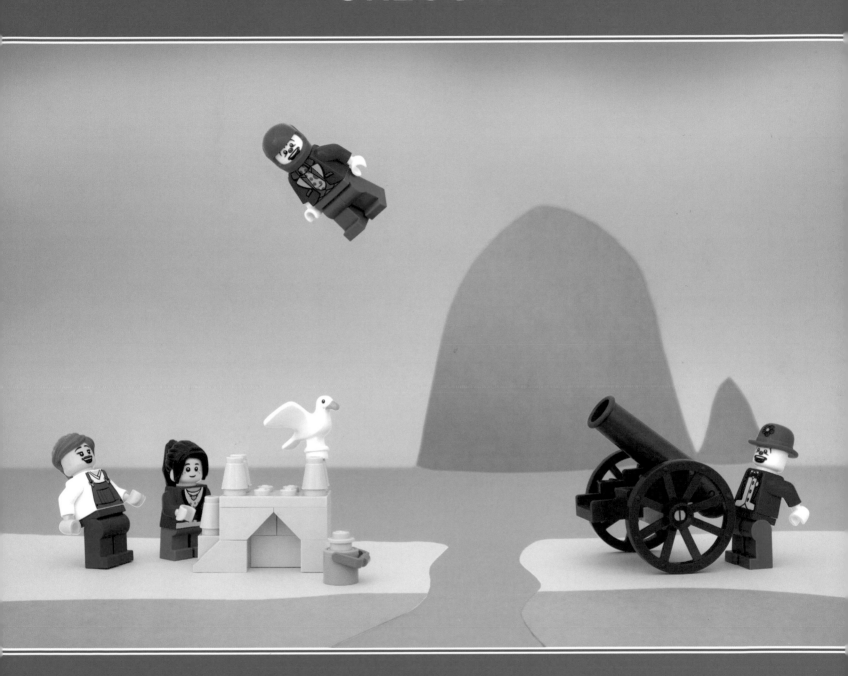

Never leave your clowns unattended at Cannon Beach.

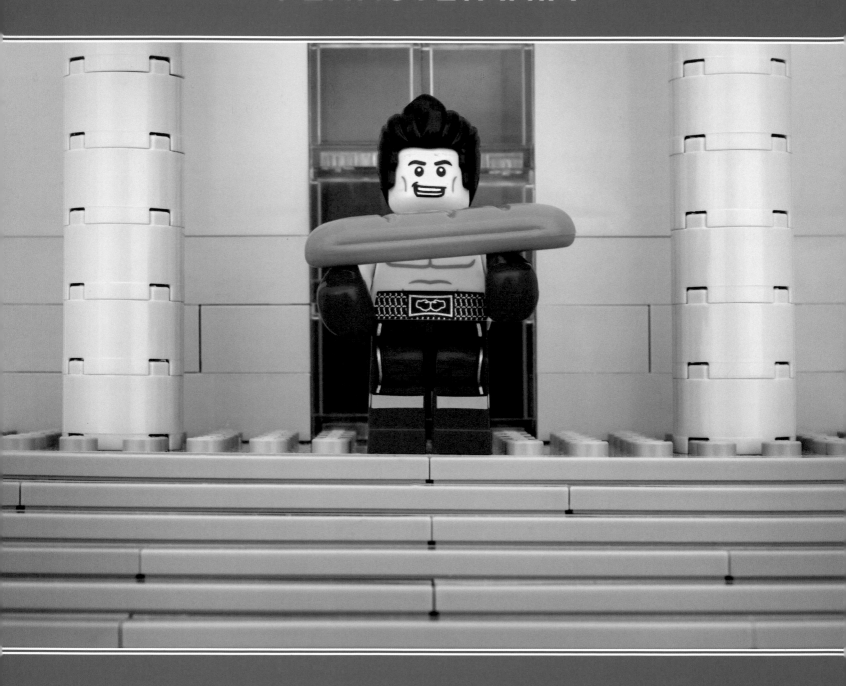

The heavyweight cheesesteak champion is also a patron of fine arts museum stairways.

PENNSYLVANIA

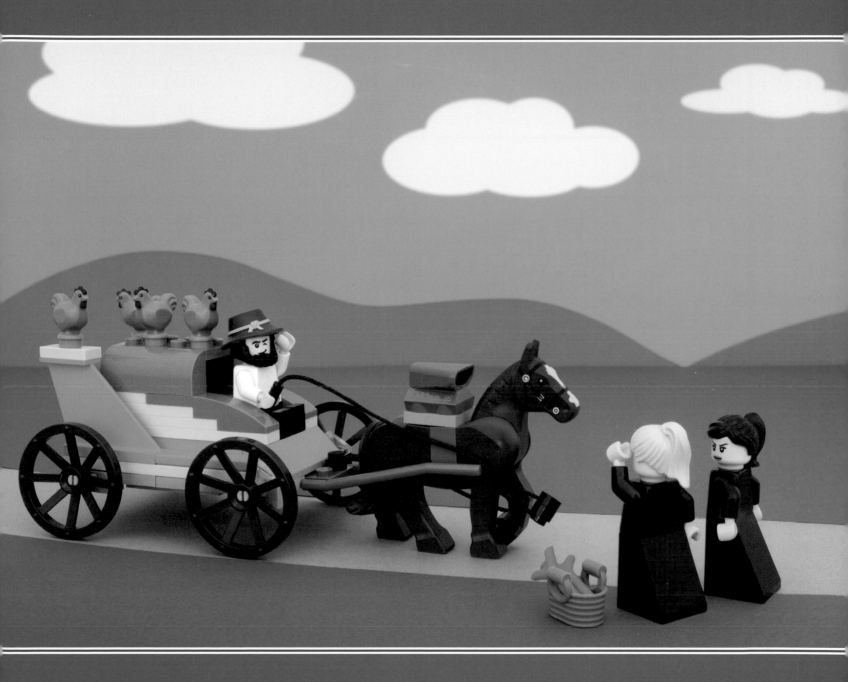

Uncle Abe picks up the chicks (and full-grown chickens as well) in his tricked-out carriage.

PENNSYLVANIA

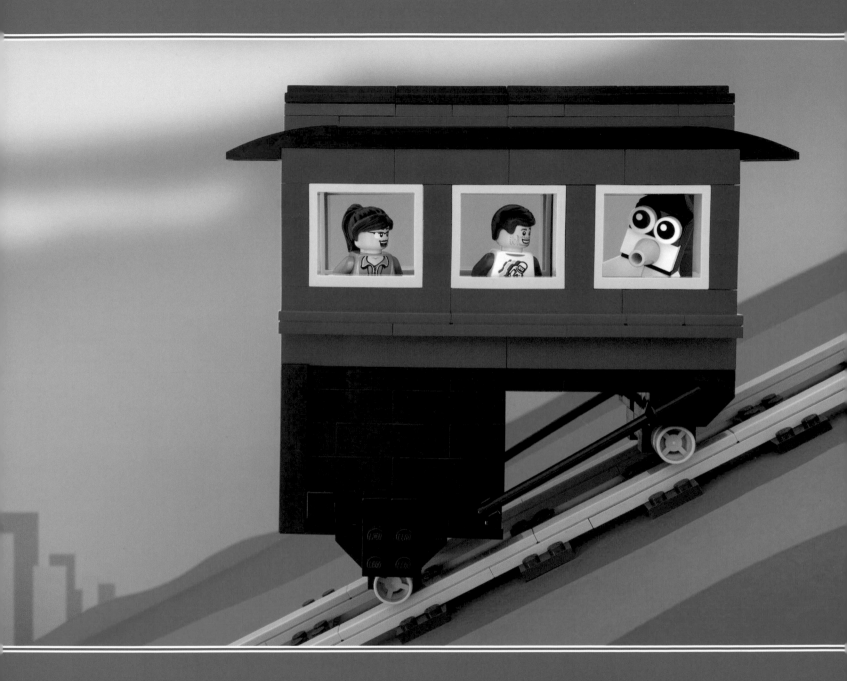

Lucky tourists on the Duquesne Incline spot a
Pittsburgh Penguin off the ice.

RHODE ISLAND

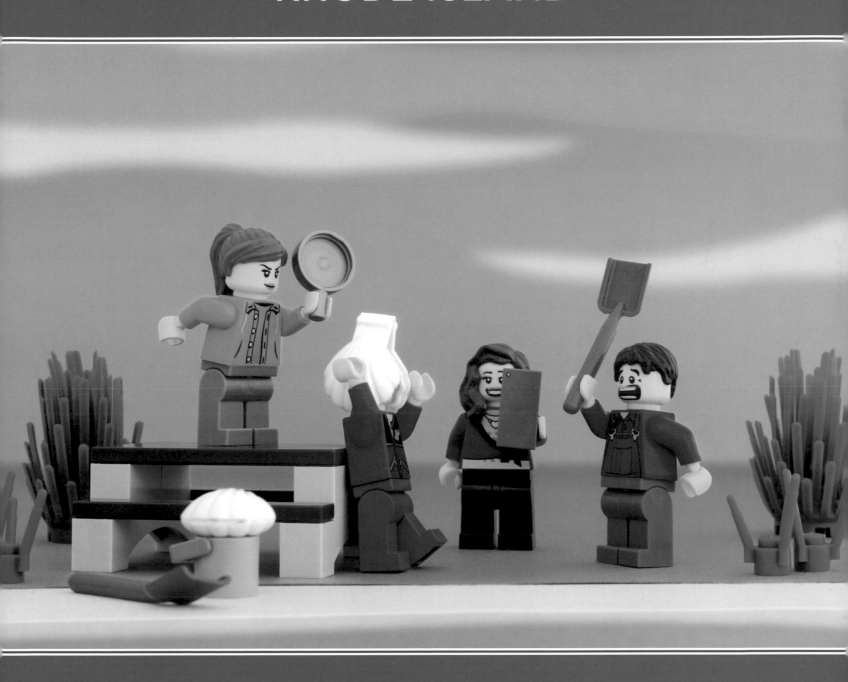

Sometimes a quahog decides to stuff itself.

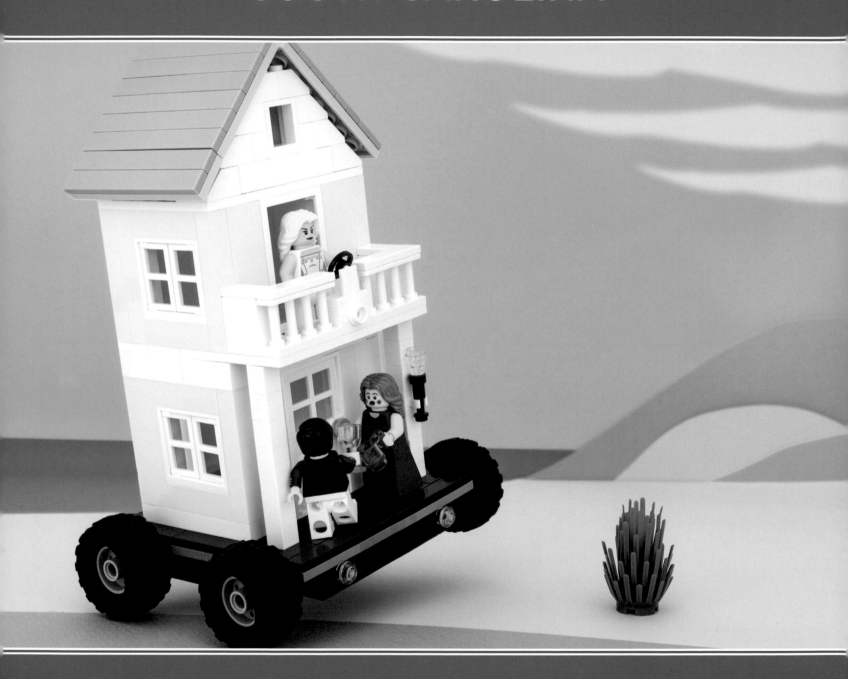

Annie May mixes Southern culture both genteel and otherwise in her customized off-road Charleston house.

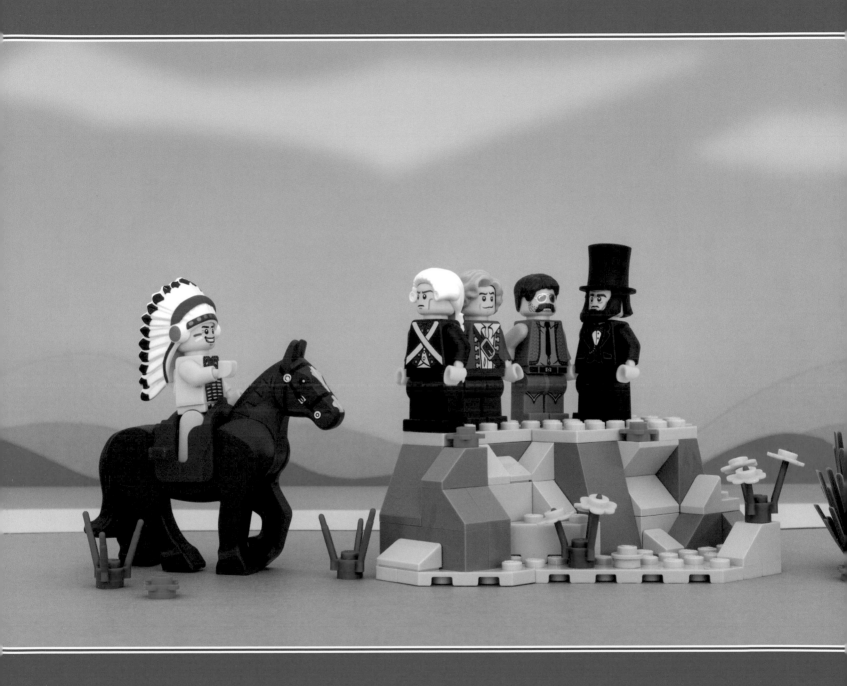

A chance encounter provides inspiration for
a large-scale sculpture in the Black Hills.

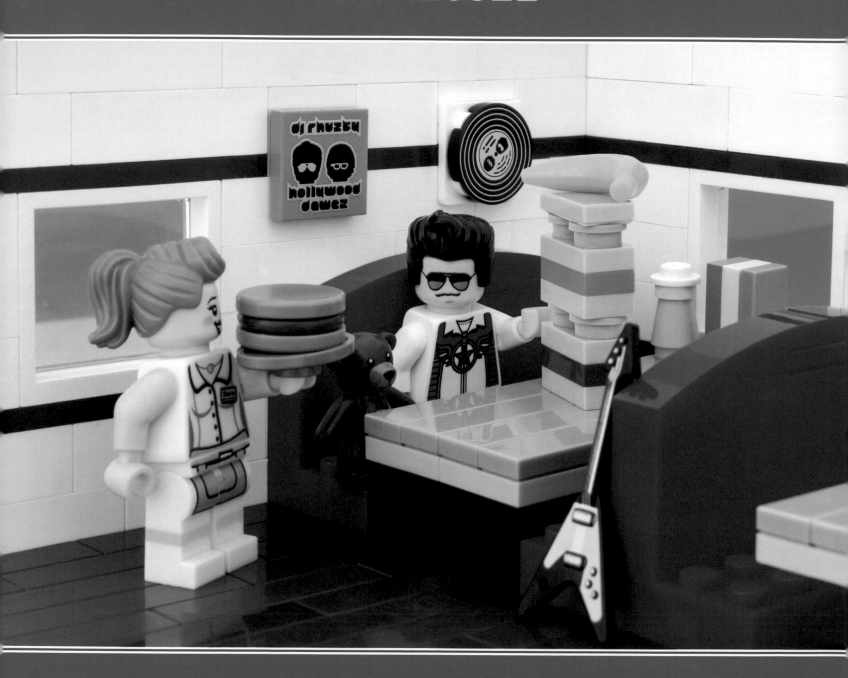

One can't help falling in love with a peanut butter, banana, and bacon sandwich.

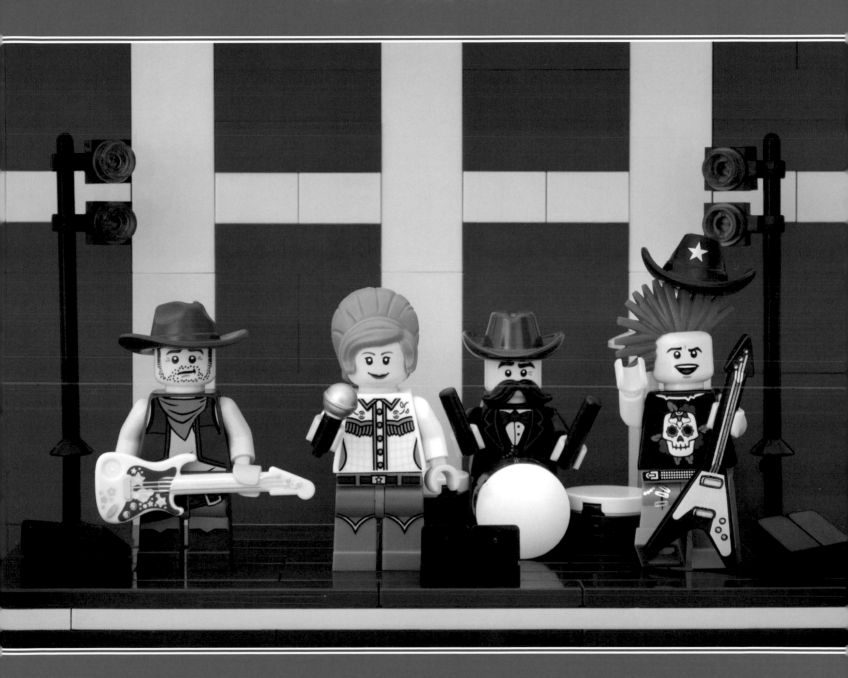

There's one in every family: the spiky-haired magenta sheep.

TEXAS

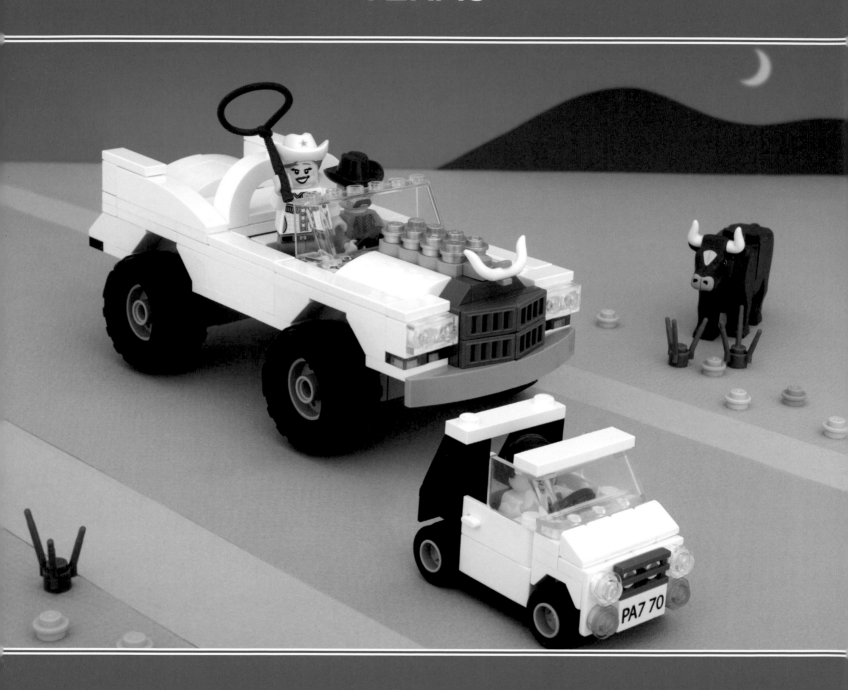

Rounding up the little doggies who've lost their way.

TEXAS

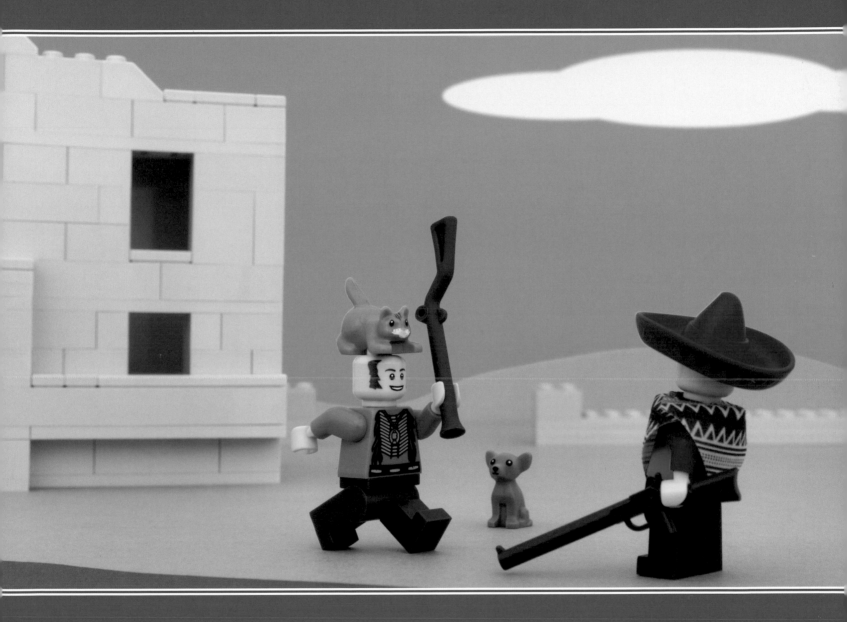

Before the raccoon fur hat appeared, Davy Crockett wore his cat, Miss Taffy, atop his head in order to bamboozle foes. It worked well until Davy accidentally inhaled a falling hairball during battle.

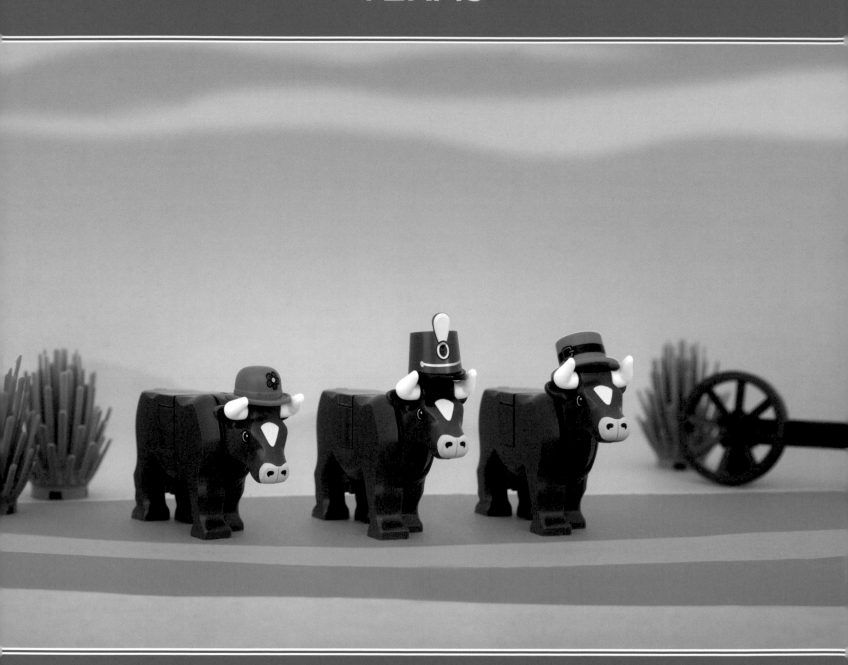

All hat and no cowboys.

UTAH

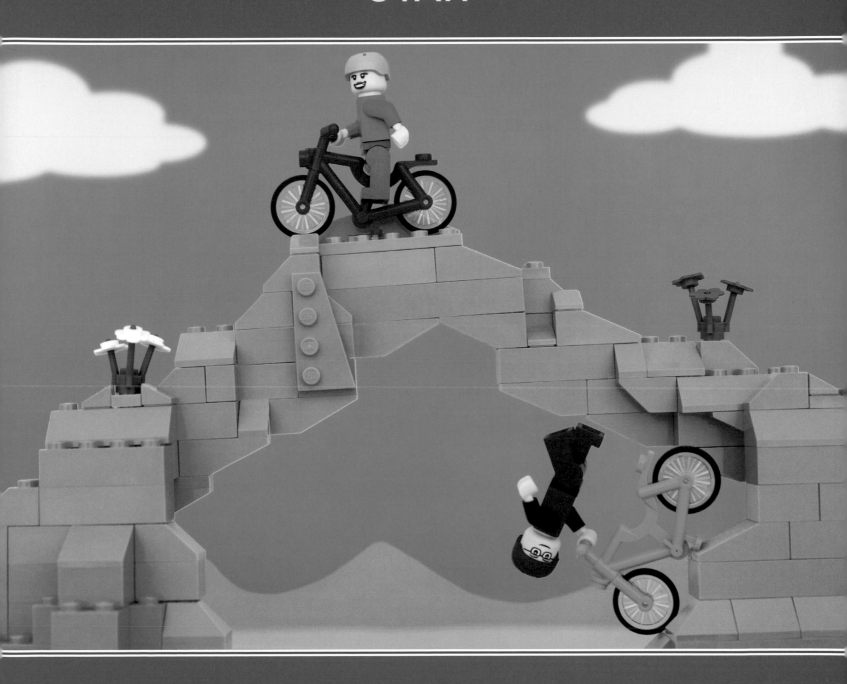

Delicate arches and delicate noggins collide in the Utah backcountry.

UTAH

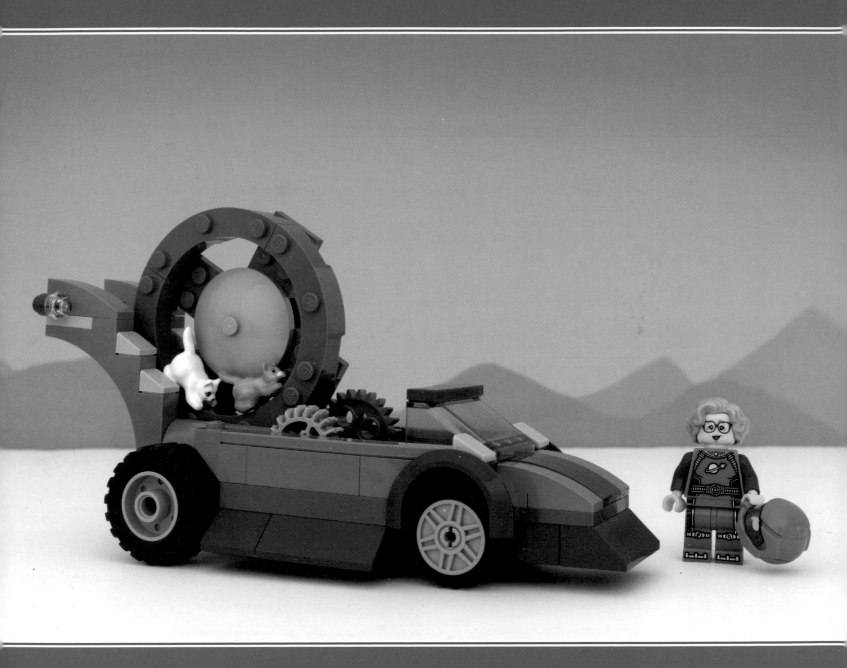

Betty arrives at the Bonneville Salt Flats hoping to break the speed record for a cat-wheel-powered car.

VERMONT

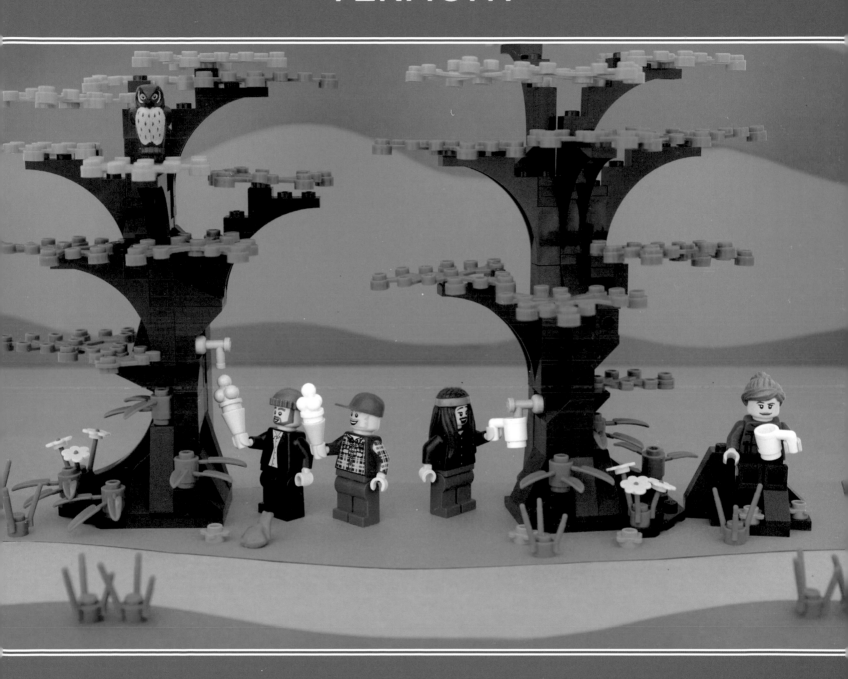

Vermont is celebrated for playing a crucial role in 1983's hit song, "Sweet Trees (Are Made of This)."

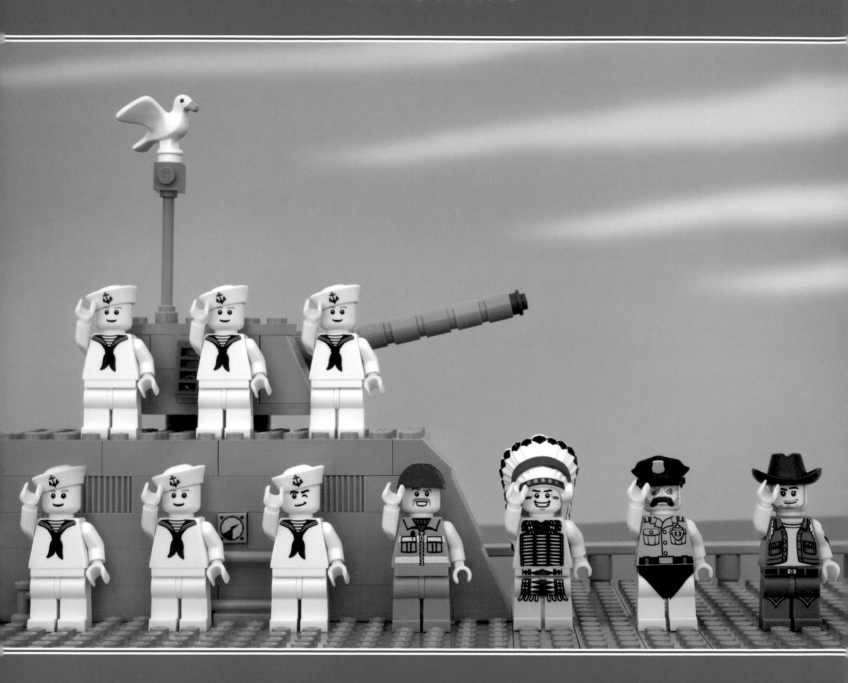

In the Navy you can do just what you please.

VIRGINIA

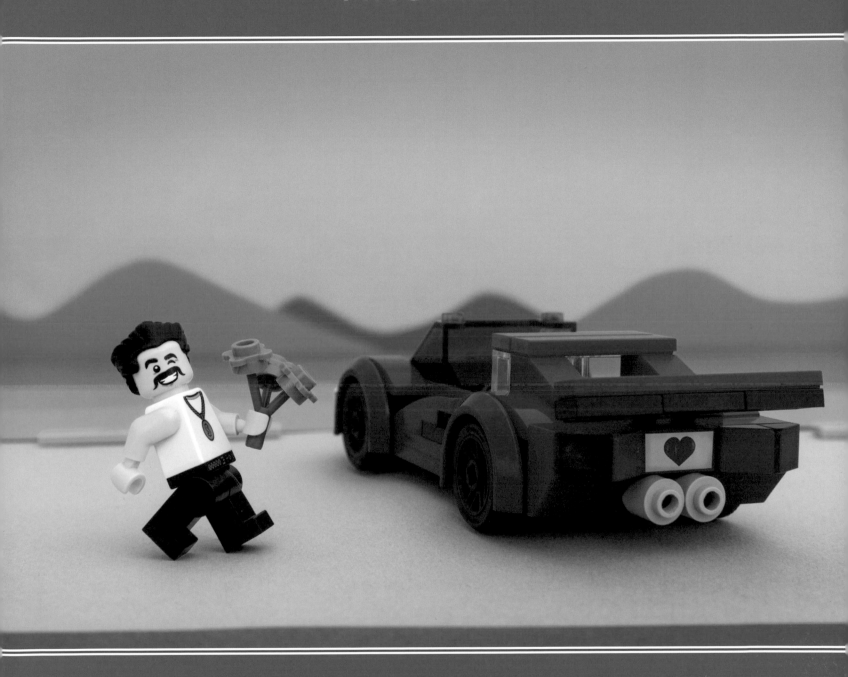

They try to warn you: Virginia is for lovers.

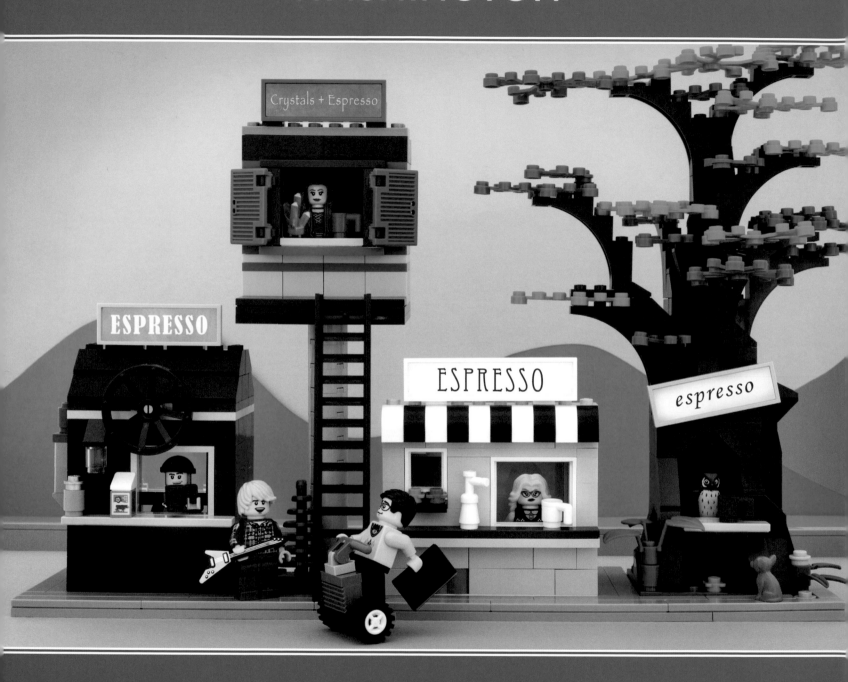

We can only close our eyes using clothespins.

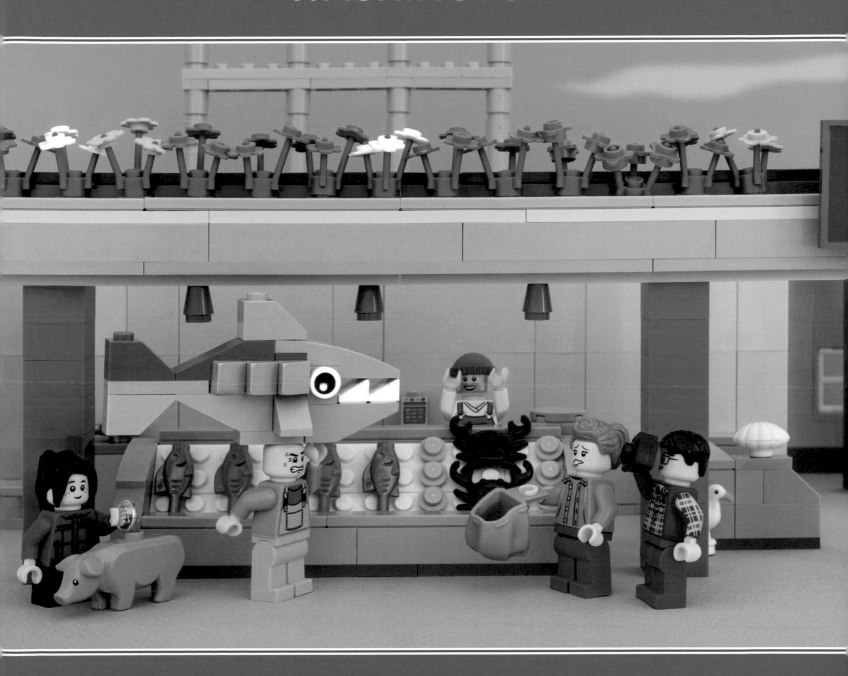

Once in a career, every Pike Place Market fish thrower encounters his or her own personal Moby Dick.

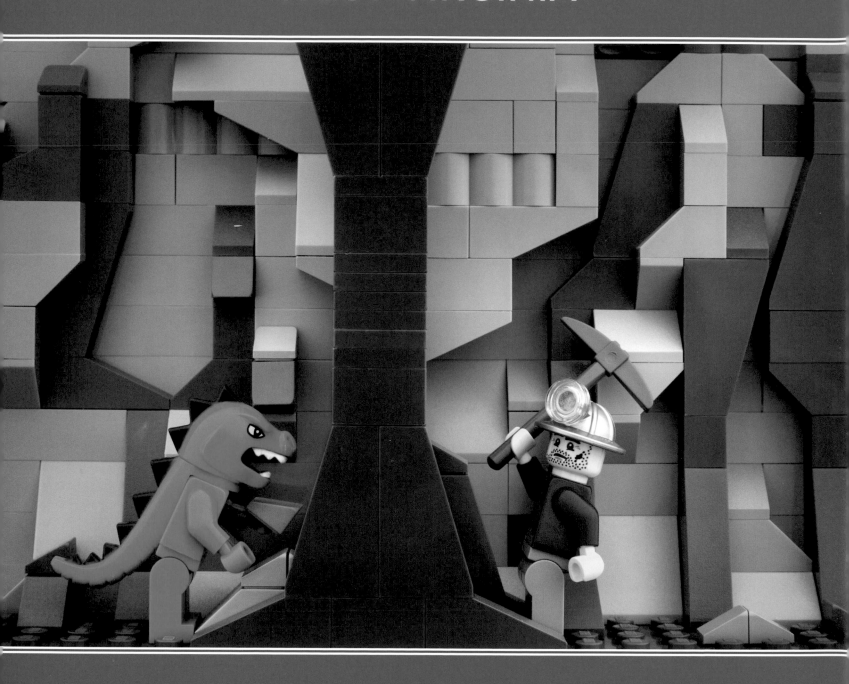

There's just five minutes left of Bobby's uneventful
shift in the mine.

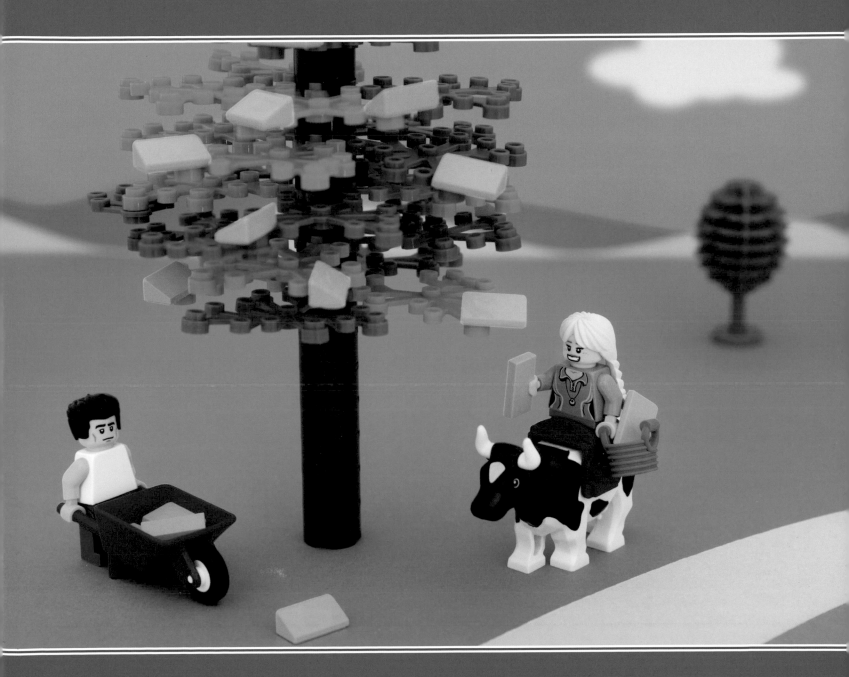

After jumping the shark, Arthur Fonzarelli limits his outdoor activities to helping with the traditional Wisconsin cheese harvest.

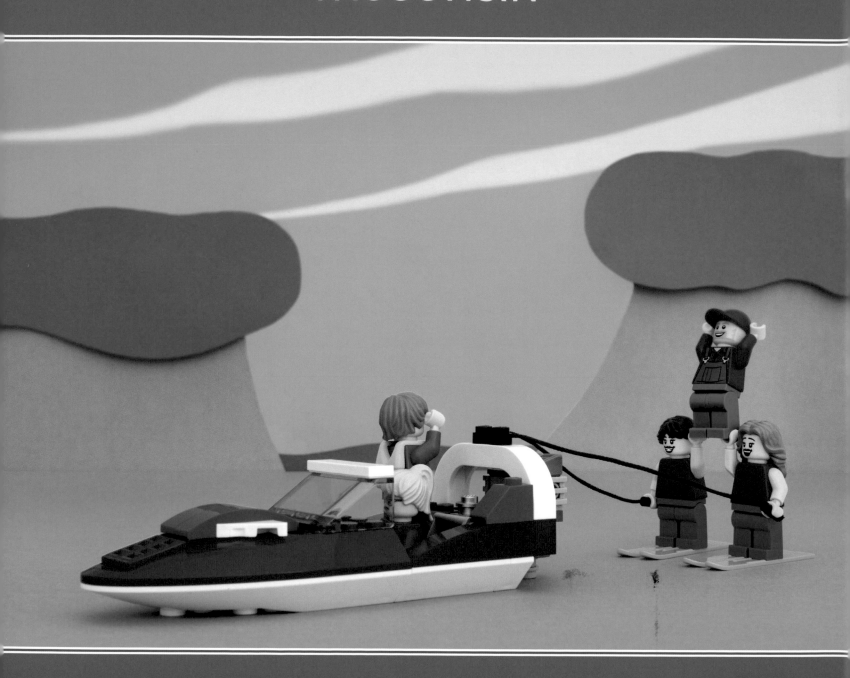

Hi-ho the dairy-o, a farmer in the Dells.

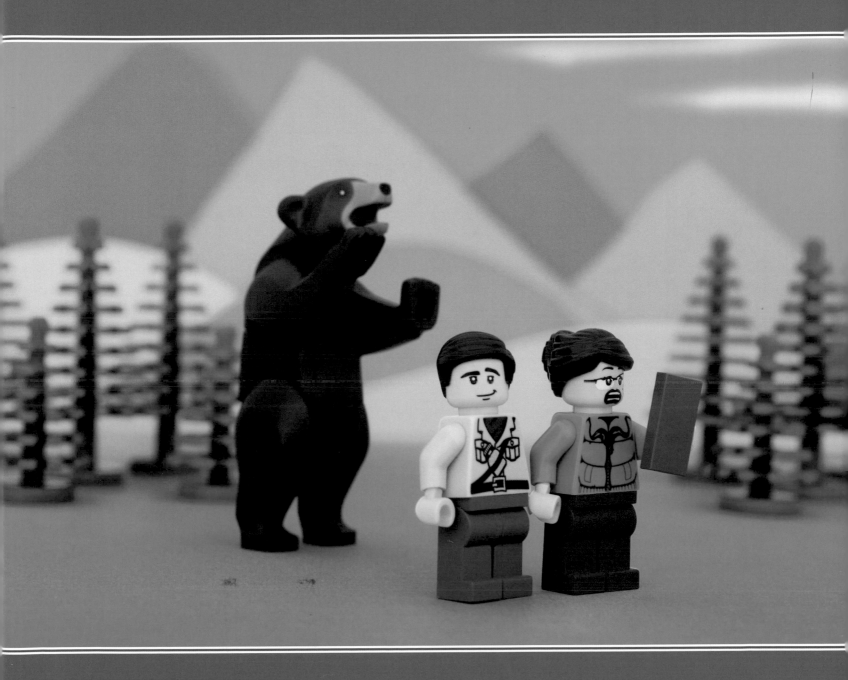

Never feed Yellowstone's grizzly photo bombers with the attention they so wildly crave.

WYOMING

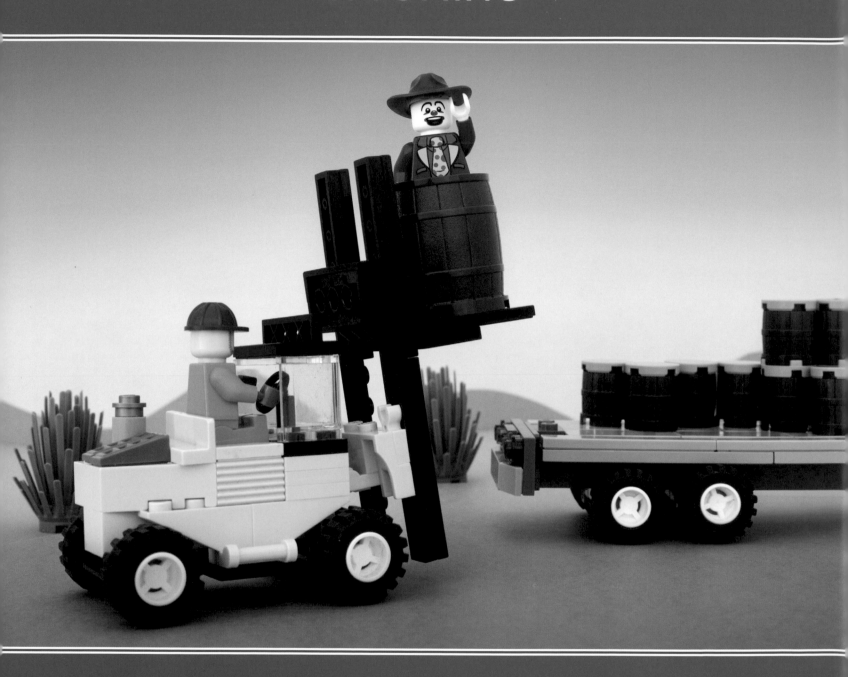

After the annual Cheyenne Frontier Days have ended, rodeo clowns are safely stored away in their barrels until next year.

Acknowledgments

The overwhelming support for *United States of LEGO* and *50 States of LEGO* (the photo series from which the book originated) is humbling, and I wish to thank everyone who has enjoyed the work and shared it with friends and family.

Jakob Schiller, a writer for *Wired* magazine, was the first person to introduce *50 States of LEGO* to a wide audience in *Wired*'s excellent RAW File department.

I am grateful to Lisa Miller of the *Huffington Post*, Aaron Calvin of *Buzzfeed*, and Laura Vitto of *Mashable* for featuring the work to their scores of readers. I would also like to thank Kimber Streams of *Laughing Squid*, Jeff Wysaski of *Pleated Jeans*, and Sara Barnes of *Brown Paper Bag*, along with the many others whose tireless work on art, design, and humor websites provides a force of good on the Internet.

This book would not exist without the amazing staff of Skyhorse Publishing. It is a joy working with editor Jenny Pierson, whose expertise is matched with sunny cheer.

My daughter, June, and wife, Tetjana, are the foundation of everything good in my life, including the work in these pages.

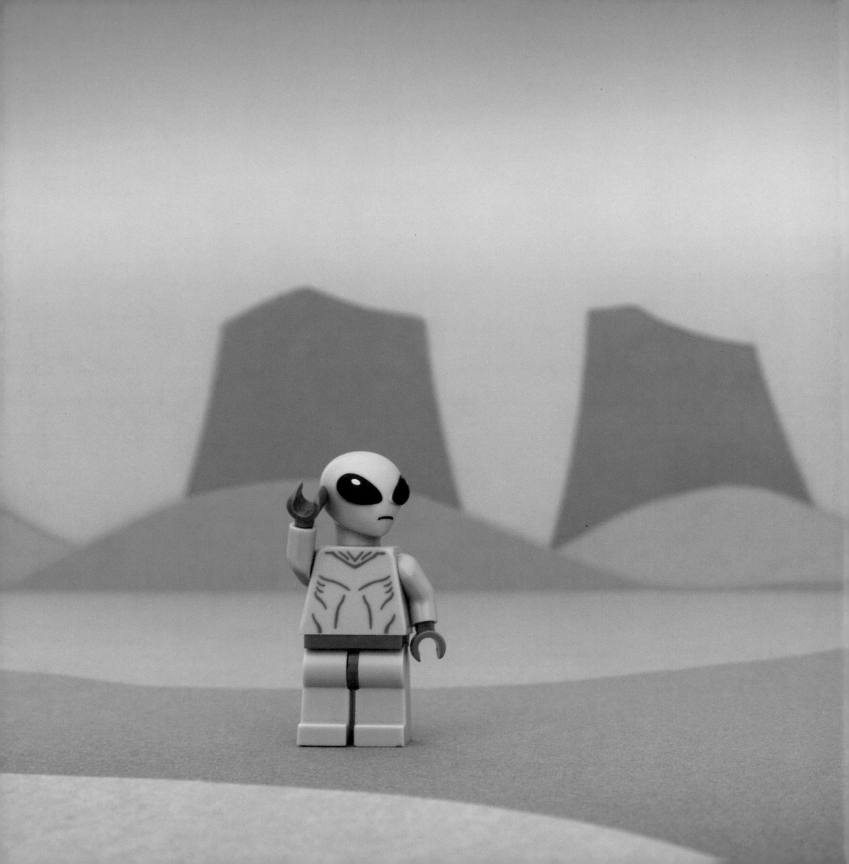

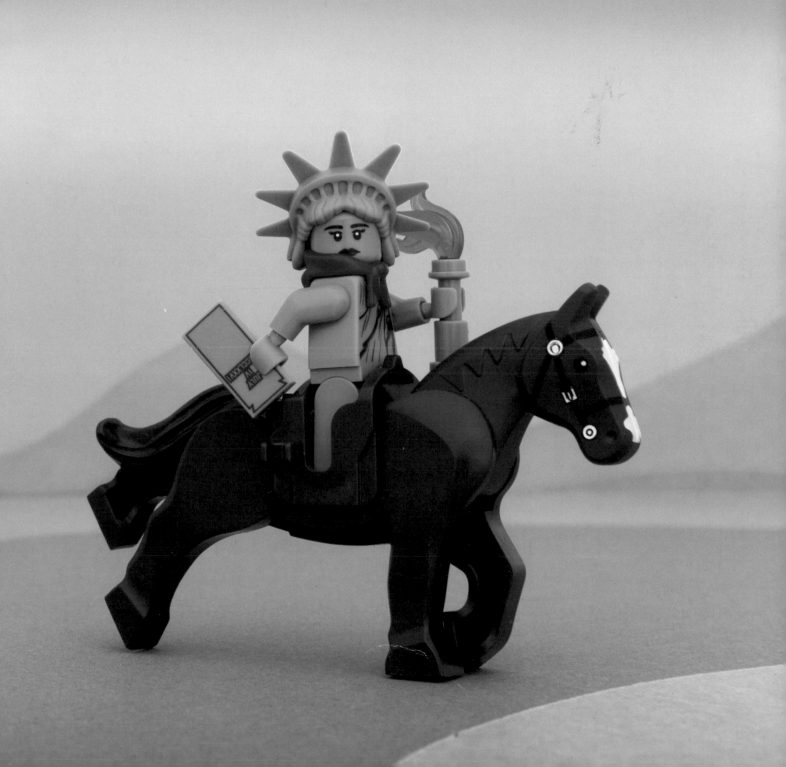